1951-2004

architecture

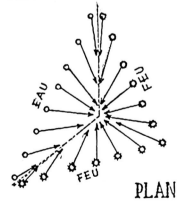

PLAN

This book was published on the occasion of the exhibition
"Yves Klein: Air Architecture"
at the MAK Center for Art and Architecture, Los Angeles (May 13 - August 29, 2004).

Exhibition:	Peter Noever, Kimberli Meyer, François Perrin
Curator:	François Perrin
MAK Center Curator:	Kimberli Meyer
Exhibition Design:	François Perrin
Editors:	Peter Noever
	François Perrin
Editorial Assistence:	LouAnne Greenwald
	Kimberli Meyer
Copy Editing:	Rebecca Epstein
Graphic Design:	Axel Prichard-Schmitzberger @ hostcell
Translations:	Nicole Battefort

The editors would like to thank Rotraut Klein-Moquay and Daniel Moquay for their original support and generosity; Philippe Siauve at the Yves Klein Archives for his endless help and good spirit; Claude Parent, Roger Tallon, and Werner Ruhnau, the *"air architects,"* for sharing their memories; the late Pierre Restany for his last thoughts; Nicole Battefort for her involvement; Brigitte Berg for her support in Paris; and Marie Jager for keeping her sharp mind.

This exhibition and publication is made possible in part by the Federal Ministry of Education, Science, and Culture and Federal Chancellery, Department for the Arts of the Republic of Austria; The National Endowment for the Arts; The LaFetra Family Foundation; The Los Angeles County Arts Commission; The City of West Hollywood; and Etant Donnes (the French-American Fund for Contemporary Art).

MAK Center for Art and Architecture, Los Angeles
835 North Kings Road, West Hollywood, CA 90069, U.S.A.
Tel. (+1-323) 651 1510, Fax (+1-323) 651 2340
E-Mail office@MAKcenter.org, www.MAKcenter.org

Published by: Hatje Cantz Verlag
Senefelderstrasse 12, D-73760 Ostfildern-Ruit, Germany
Tel. (+49-711) 4405-0, Fax (+49-711) 4405-220
www.hatjecantz.de

Distributed in the U.S. by: DAP/Distributed Art Publishers, Inc.
155 Avenue of the Americas, 2nd floor,
New York, NY 10013
Phone (+1-212) 627 1999, Fax (+1-212) 627 9484

ISBN 3-7757-1407-3
Printed in Germany

Cover/Back: Yves Klein in the *Void Room (Raum der Leere)*, Museum Haus Lange, Krefeld, January 1961. Photo by Charles Wilp.

Table Of Contents.

Beyond the Blue. Peter Noever.

The *"Leap into the Void"* - into space, which is neither stage nor scene of representation, not merely packed with ideas, but itself pure intensity, pulsating energy - was one of the principal utopias pursued by Yves Klein as a painter and moving force of twentieth century avant-garde art.

His blue monochromes concentrated all the traditions and formal relationships of painting, from the *"spatialization"* of the image to the adequate representation of a spiritual reality pervaded by transcendence and the formal consequence of abstraction, all the way to the leap from the frame into artistic action.

Yet Klein, transported by the utopia of boundlessness - of liberation from contours, of exposure, of de-objectification - aimed farther and higher. He sought to go beyond the representation he had found in the color blue in his very own eye-opening blue. The space created by the color blue was the actual intent: It is an open - infinitely open - space extending towards the observer into which we can spiritually enter. Yet in another dimension, as the blue is carried by a canvas or comparable support, it is still merely a representation or, in Klein's own words, composition.

His search for ways of promoting the trend of *"immaterialization"* in art led Klein to experiment with air and heavy gases as carrier elements, and to develop the idea of creating horizontal and vertical surfaces by means of jet-sprayed flammable gases or compressed air. Color space, the energetic aspect of his work, was thus to become one with itself: free sensitivity.

It was merely a matter of stringency that at this point, in his efforts to open up artistic space with his concept of *"climate-controlled architecture,"* formulated with Werner Ruhnau in the course of their work on the new theater building of Gelsenkirchen in Germany, Klein encountered architects striving to achieve the greatest possible integration and to overcome the separation between interior and external spaces. If Klein sought to move painting towards a free sensitivity liberated of all the constraints of objectiveness by using air or heavy gases, this concept at the same time prepared the ground for the idea of completely dynamic architecture. Architectures made of air would open up not only public buildings such as theaters to the city and make them transparent; they could serve to insert entire cities, comprehensive cultural spaces into given natural conditions as climate-controlled habitats.

The MAK Center at the Schindler House, with R. M. Schindler's porches as open-air bedsteads, and interiors open to the outside, provides a compelling backdrop for the presentation of this hitherto little-regarded contribution of Yves Klein's art to contemporary architecture. The house is one of the birthplaces of that modern architecture that matched Klein's artistic intent in the first place - floating architecture (Frei Otto and Walter Behnisch), which is perpetuated to our day as *"flaming architecture"* (COOP HIMMELB(L)AU), as dynamic architecture (Zaha Hadid), and articulates the persistent topicality of the artist's efforts to liberate sensuality and sensitivity from their historic constraints.

An essential aspect that demonstrates Klein's special connection with architecture, and which takes on particular importance here at the hub of virtuality and the images that describe it (the movie industry), is the fact that his concept of the image was not cinematographic and his idea of energy was not cybernetic. Air Architecture was not meant to visualize the invisible - movement, time, duration-its intent, indeed the intent of Klein's entire oeuvre, was liberation from the predominant compulsion to make visible or at least imaginable. As an artist, Klein sought not to depict heaven - neither in the literal nor in the figurative sense - but to make it accessible. Like no other painter or artist, he aimed to assert the mythical ban on the graven image: to enable us to truly see by decomposing all images, deconstructing the devices that created them, invalidating our imagination so that we can perceive what is real beyond the walls of time.

Air Architecture: Imagination and Matter.
François Perrin.

All the people that love the great-simplified dream, in front of a sky that is nothing but the world of "transparency," will understand the vanity of "apparition." For them, "transparency" will be the most realistic appearance. It will give them an intimate lesson of lucidity.[1]

The architecture of the future will be for the people.[2]

Man is no longer the center of the universe, it is the universe that is the center of man.[3]

From 1957 to 1962, Yves Klein imagined the Architecture of Air: a visionary project of living environments reconnecting people with the earth and its elements. It was the dream of an architecture that engaged the climate at the origin of its design process, with an ultimate goal to radically transform society. Klein's architecture was a social project; he wanted to provide the ideal environment for humans on the planet because he was aware that despite the advent of space odyssey, the Earth and its atmosphere would be our only future.

Man will never conquer space with rockets, sputniks or missiles, because in this way he would remain a tourist in this space; but he can conquer space by inhabiting it through sensibility.

In 1992, I completed my architectural studies in Paris and by chance discovered this project. The advantage of studying at the Beaux-Arts was not the historical buildings and decaying architectural education, rather it was only a walking distance from the museums, galleries and bookstores that made for my real education. Through a rare exhibition of blue monochromes, I discovered the pictorial climate and Klein's architectural theories in the published lecture he gave at the Sorbonne in Paris, June 3, 1959.

Air, gas, fire, sound, odors, magnetic forces, electricity, electronics are materials. They must have two main functions, namely: to protect against the rain, the wind and atmospheric conditions in general and to create thermal air conditioning.

Hurricane Alberto. August 19th, 2000.

1

Klein's project was to modify the climate at the surface of the earth to create the conditions of a new Eden. The climatic conditioning of large geographic space would allow people to live outside in a new community. Klein's proposal for building was an inverted architecture where the existing structures were placed underground to create space, using only natural elements such as air, water, and fire.

> Air Architectures must be adapted to the natural conditions and situations, to the mountains, valleys, monsoons, etc., if possible without requiring the use of great artificial modifications...

Klein proposed the use of air as an envelope to serve as a protection from the weather. Fire and water provided control of the climate. Furniture was produced with pulsated air, creating beds and platforms where people could interact.

Klein's lecture at the Sorbonne outlined a broad scope of interest beyond design. His exploration of architecture was not a formal one; rather, he understood it in its broader role within the world economy, politics, and society. In other words, what architecture is actually about.

The story started with travel. When visiting another country you notice how climate really functions, how it impacts the local geography. During a trip to Spain in 1951, the experience of a water fountain gave Klein ideas *"capable of revolutionizing the world"* through the air conditioning of the earth.

> The functional-psychological goal of water jets on stretches of water is to bring a general coolness...

Klein spent his youth traveling. First, with frequent trips shuttling between Nice, where he was born in 1928, and Paris, where his parents lived. Then, as a teenager exploring postwar Europe, he spent months in foreign countries such as England, Ireland, Italy, and Spain. In 1952, at the age of twenty-four, he embarked on a long journey from Marseille to Asia. He stayed for a year in Tokyo perfecting his new passion - judo.

This fundamental experience practicing a martial art informed his vision of architecture and space. One of the principles of judo is to use the strength of one's opponent in order to control him; to produce the right and necessary movement in an economy of action. This attitude can also be found in Japanese architecture, in its minimal use of materials and details as well as in its relation to the elements, its ability to accept or reject external conditions in order to create a continuous indoor-outdoor relationship.

Also at the core of Klein's theories are the literary influences of books he read throughout his life. The comic books of his childhood (Mandrake, the magician in a tuxedo who makes people disappear, and Tintin, the globe trotter who encounters levitating monks in Tibet) and the teenage years when he read the *Rosicrucian Cosmogony*, a book that introduced him to the visible and invisible worlds, *"The changing nature of the dreams makes it similar to the ethereal part of the physical world."*

It is in the texts of Gaston Bachelard, the philosopher of matter, that Klein discovered his biggest influence at the beginning of his practice. Before *The Poetics of Space*, Bachelard wrote four thematic books on the elements: air, earth, fire, and water. Klein often quoted him to illuminate his work. The theories explaining the invisible connections of imagination and matter are key to Klein's architectural visions and statements. At the beginning of *"Water and Dreams: An Essay on Imagination and Matter,"* Bachelard makes the distinction between the formal imagination and the material imagination:

Some get their impetus from novelty; they take pleasure in the picturesque, the varied, and the unexpected. The imagination that they spark always describes a springtime. In nature these powers, far from us but already alive, bring forth flowers. Others plumb the depths of being. They seek to find there both the primitive and the eternal. They prevail over season and history. In nature, within us and without, they produce seeds - seeds whose form is embedded in a substance, whose form is internal.

Klein found in the *"Imagination of Matter"* the foundations of his art. He also had a strong knowledge of the history and evolution of art, since both his parents were painters active in the Parisian art scene. In a typically rebellious teenage move, he wanted to break away from common art practice. Paris in the fifties saw the emergence of new intellectual movements. Amidst the Lettrists with whom he published his first manifesto, and the Situationists with whom he hung out, he looked for a new way to practice art and engage people in it. Their fate and ideologies crossed paths, but their intentions remained the same.

For his first personal show in 1957 at the gallery of Colette Allendy, he introduced sculptures, an environment, pure pigment, a screen, a fire painting, and the first *Immaterial* (a totally empty room). He announced the future developments of his art, and a practice oriented towards space rather than the object. At the same time, at the gallery of Iris Clert, he began his *"Pneumatic period"* with the opening of the exhibition of blue monochromes. That day he released 1001 blue balloons into the sky of Paris.

One year later, for his thirtieth birthday, he presented again at Iris Clert. It was the exhibition of the *Void*, where he repainted the gallery white to reveal its own space. Possibly the first *"white cube"* of contemporary art, this installation announced several future experiments, but also Klein's departure for new directions. That same night he organized the lighting of a famous public square, his *Blue Revolution*.

While these works reflect Klein's transition toward the realm of architecture, it is his meeting with the German architect Werner Ruhnau and their collaboration on the Gelsenkirchen Opera that actually initiated Air Architecture. During the forty months of construction, Klein would find himself in direct contact with architecture.

Werner Ruhnau and I regard cooperation in art as having always been most important and human.

Their first project was the design of an outdoor plaza in front of the Gelsenkirchen Opera. Werner Ruhnau used white chalk to draw on black paper an environment of air, fire, and water. Such was the *"air cafe,"* with its invisible roof protecting people from the rain, and fire and water fountains that provided an outside air-conditioning to the surrounding area.

My walls of fire, my walls of water are, with the roofs of air, materials for a new architecture. With these three classical elements, fire, air and water the city of tomorrow will be constructed; it will at last be flexible, spiritual and immaterial.

Another Klein-Ruhnau project was the creation of a Center of Sensibility. It was their updated version of the Bauhaus, where twenty visiting artists would participate to train students in the practice of imagination and matter. He presented this project with a detailed budget in *"The Overcoming of the Problematic of Art,"* published in 1959. The building, like its model in Dessau, was to be the central element.

The immaterial architecture will soon be the main facet of this center. It will be flooded with light.

During a short trip to Paris in April 1959, Klein obtained the patents for their first designs (air roof, fire and water fountains) hoping to build soon. He began to work with the French architect Claude Parent on drawings for the fountains of fire and water as well as the first sketches of *"immaterial"* housing and cities. Later that year, Klein gave a lecture at the Sorbonne on *"The Evolution of Art Towards the Immaterial,"* in which he first presented the Klein-Ruhnau theory of Air Architecture.

First of all, blue light as a building material, corresponds to void: Energy must be used in the stratosphere; in the atmosphere heavy-air or any other gas that is heavier or more dense than air will be used as building material, also using optical fire effects, magnetism, light, and sound. Sound will be used against sound in order to neutralize it. On the ground, mortar, concrete, stone, clay, and iron will of course be used as building material.

In January 1961 at the museum Haus Lange, Krefeld (an art collector's house designed by Mies Van der Rohe), a retrospective of Klein's work showed the first prototypes of fire walls and fountains. Klein worked with the Küppersbusch Factory (where, since 1958, he had been making experiments). A fire column erupted from the ground next to a firewall composed of fifty individual flames. Inside the house was a white empty room (still a permanent piece in the museum) acting as a breath through the exhibition. Films and photographs of spectators gathering outside around the fire documented this ephemeral installation.

After showing in New York and Los Angeles, Klein returned to Paris and started new projects with Claude Parent, such as *Les Fontaines de Varsovie* facing the Eiffel Tower. In early 1962 at the Musée des Arts Décoratifs, he presented a synthesis of his Air Architecture projects with some prototypes made by the designer Roger Tallon. This was his last exhibition and the end of the story.

A few years later a decade of radical architecture production began all over the world, peaking in 1968 with the violent events of the spring that briefly transformed the Western social structures. Archigram in England followed the steps of Cedric Price and his joyful mobile constructions and they imagined moving environments that reflected our accelerated cultures. Superstudio in Italy diverted object production to stage a narrative version of the evolution, their futuristic illustrations showing people from all generations in a new reactivated geography. Elsewhere, groups of architects explored different directions. The use of air as a material for the form of pneumatic structures was a common experiment for many propositions and constructions. The energy crisis of the mid-seventies put an end to this movement.

Artists of the same period continued to explore what Pierre Restany (describing Klein and the New Realists) calls *"the new perceptive approaches of the real."* In California, Light and Space artists (e.g., Robert Irwin, James Turrell) developed work based on perception and sensory experiences, creating light projections in a specific geometrical space. In 1966, another L.A. artist, Michael Asher, in his reconsideration of the work of art, started doing installations of invisible air curtains, continuing afterwards with the subtle diversion of the architecture of contemporary art institutions. In 1968, the participants to the seminal *"Earthworks"* exhibition at the Dwan Gallery in New York (e.g., Michael Heizer, Robert Smithson) announced their departure from the gallery space to produce in a direct contact with nature. A few years later, Gordon Matta-Clark, a former architecture student, introduced *Anarchitecture* as a rethinking of architecture and space through the production of void.

Superstudio. 1973. L'acampamento.
"The Camp," Christiano Toraldo di Francia, Adofo Natalini, Piero Frassinelli, Alessandro Poli, Alessandro Magris, Roberto Magris.

2

And then, another big void. The triumphal return of the object at the beginning of the eighties was the incarnation of an openly materialist society. It transformed the art and architectural landscape in a debauchery of formal expressions, with the necessary historical and theoretical references to better validate the profound lack of meaning.

The latest turn of the century and its usual economic, ecological, and political disruption introduced a far more complex and interesting situation. The recent technological leap announced the radical transformation of the practices, but also helped to understand new sensitive phenomena of the planets.

Forty years later, the Architecture of Air reappears under predicted signs. Immaterial communities are emerging and some artists are reintroducing the idea of cooperation in their work. Modern design is exploring new materials, more fluid and invisible, to merge these new realities. And as the Earth's climate mutates, architects, landscapers and urbanists understand at last that it is time to adapt their production.

Klein's revolutionary architectures are still hidden behind the omnipresence of his paintings and sculptures. But his work on the immaterial is the object of a new interest. This book presents a collection of Klein's writings, manifestos, sketches, and pictures, as well as drawings that illustrate his visions, products of the collaboration with the architects Claude Parent and Werner Ruhnau. These people as well as designer Roger Tallon and art critic Pierre Restany offer a retrospective look on Klein's architecture.

The presentation of this material is not a memorial or archeological report, nor is it a nostalgic tribute to his person. Rather it is a reactivation of Klein's ideas in a contemporary context. It is also an opportunity to present a new perspective on Klein's entire practice-one that is beyond the cult or the polemics often encountered. By looking at the artist's production through his architecture, we have a new logical and poetic understanding of his work. And that is the quality of some artists; to remain relevant through the times.

Notes.

1 Gaston Bachelard, "Air and Dreams," Librairie José Corti, 1943, Paris, France.

2 Oscar Niemeyer, "The Architecture of the Future will be for the People." Interview by Rolande Leroy in "L'Humanité," January 23, 1998.

3 All Yves Klein quotes are taken from the lecture at the Sorbonne, "L'évolution de l'art vers l'immatériel," Conférence de la Sorbonne, Paris 1959. Galerie Montaigne, Paris 1992.

1951-2004

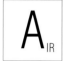

architecture

Nice, France. June 1948.
"That day, as I lay stretched upon the beach of Nice, I began to feel hatred for birds which flew back and forth across my blue sky, cloudless sky, because they tried to bore holes in my greatest and most beautiful work." - Yves Klein

Madrid, Spain. February 1951.
"I was in bliss at the Granja summer palace... that's where I imagined replacing the elegant jets of water on the tranquil surface of the pools with brilliants jets of fire."
- Yves Klein

3

4

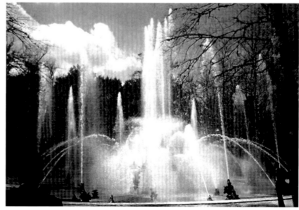

Tokyo, Japan. 1952.
Kodokan Judo Institute

5

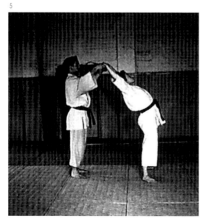 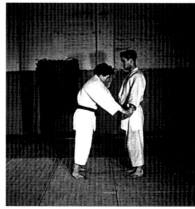 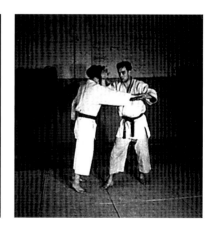

Paris. May 10, 1957. 7 >
"A Thousand and One Blue Balloons
Released," Exhibition: "Yves le Mono-
chrome," Galerie Iris Clert, Paris.

Paris, France. May 1957.
"Blue Pigment on a Plastic Sheet,"
Exhibition: "Yves le Monochrome," Galerie
Colette Allendy, Paris.

6

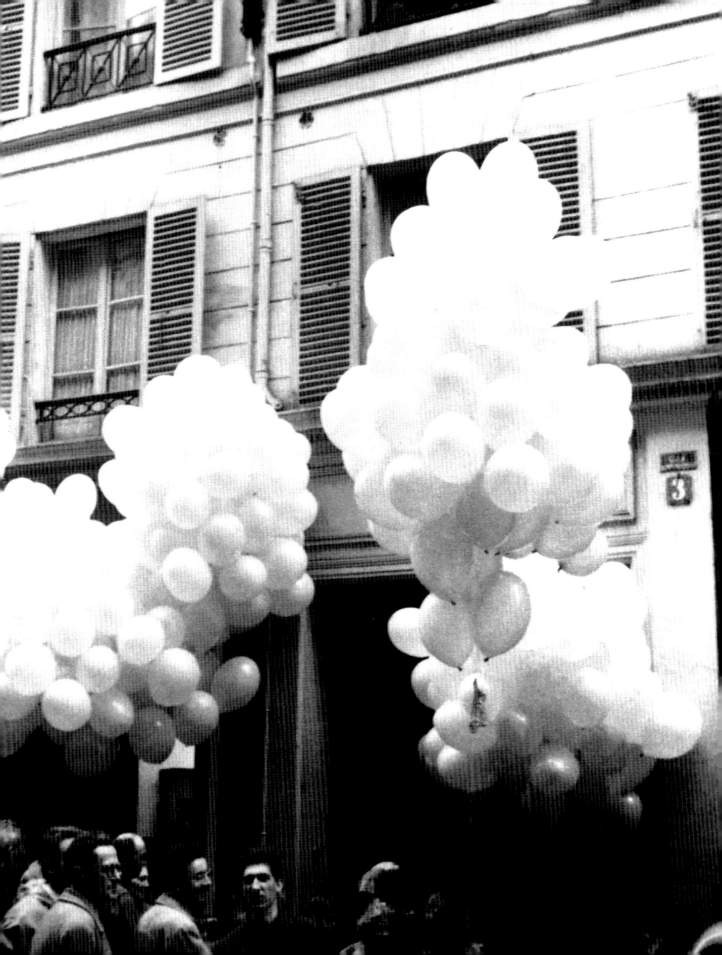

Paris, May 20, 1958.
"The Blue Revolution"
Typed letter to President Eisenhower

Paris. April 28, 1958.
Illumination of the Obelisk, Place de
la Concorde

Obélisque illuminé en bleu.
Blue Obelisk
Project, 1958, Pencil on paper,
Private Collection

8

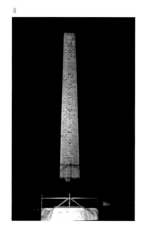

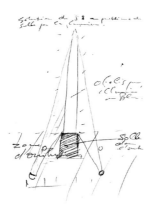

TRANSLATION

STRICTLY CONFIDENTIAL
ULTRA SECRET

"THE BLUE REVOLUTION"

Movement aiming at the transformation
of the French People's thinking and
acting in the sense of their duty to
their Nation and to all nations.

Paris, May 20th, 1958

Address: GALERIES IRIS CLERT
3, rue des Beaux-Arts,
Paris - Vme.

Mr. President EISENHOWER
White House
Washington, D.C. - U.S.A.

Dear President Eisenhower,

At this time where France is being torn by painful events, my
party has delegated me to transmit the following propositions:

To institute in France a Cabinet of French citizens (temporarily
appointed exclusively from members of our movement for 3 years), under
the political and moral control of an International House of Represent-
atives. This House will act uniquely as consulting body conceived in the
spirit of the U.N.O. and will be composed of a representative of each
nation recognized by the U.N.O.

The French National Assembly will be thus replaced by our
particular U.N.O. The entire French government thus conceived will be
under the U.N.O. authority with its headquarters in New York.

This solution seems to us most likely to resolve most of the
contradictions of our domestic policy.

By this transformation of the governmental structure my party
and I believe to set an example to the entire world of the grandeur of
the great French Revolution of 1789, which infused the universal ideal
of "Liberty - Equality - Fraternity" necessitated in the past but still
at this time as vital as ever. To these three virtues, along with the
rights of man, must be added a fourth and final social imperative: "Duty!"

We hope that, Mr. President, you will duly consider these
propositions.

Awaiting your answer, which I hope will be prompt, I beg of you
to keep in strict confidence the contents of this letter. Further, I
implore you to communicate to me, before I contact officially the U.N.O.
our position and our intention to act, if we can count on your effective
help.

I remain, Mr. President,

Yours sincerely,

Yves Klein

Paris. April 28, 1958. Le Vide.
The Void.
"The Specialization of Sensibility From the State of
Prime Matter to the State of Stabilized Pictorial
Sensibility, The Void," Galerie Iris Clert, Paris

9

10

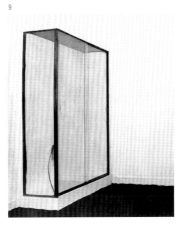

Gelsenkirchen, Germany. October 1958
Yves Klein and Werner Ruhnau conducting experiments for "Air Architecture"
at the Küppersbusch Factory.

12

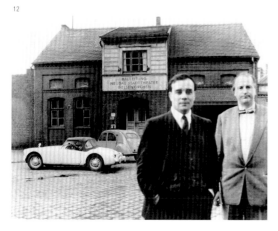

13

14

15

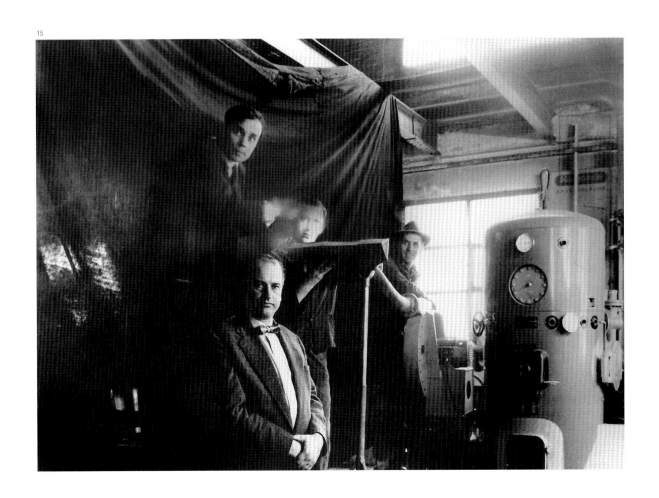

Fire, or The Future Without Forgetting The Past.
Yves Klein.

The project for a public square with a pool where jets of fire would dance instead of jets of water is an idea that dates back for me, to 1951. I was in bliss at the Granja, a summer palace of the Spanish monarchy some sixty miles from Madrid, looking at the fountains and jets of water in the gardens, similar in every respect to those of Versailles and elsewhere. That's where I imagined replacing the elegant jets of water on the tranquil surface of the pools with brilliant jets of fire.

Sculptures of fire on the water!

Why not? Well, not in a hot country. The functional-psychological goal of water-jets on stretches of water is to bring a general coolness, or at least a sensation of coolness.

For countries with a less favorable climate, where the cold reigns long in the winter, it's a luxury to present jets of water. However, it is quite functional and also aesthetic-psychological to present jets of fire on a spatial mirror base with an impassable invisible protective barrier.

That's why today I have brought back this old project, which has never been realized anywhere in the world and I'm quite astonished in truth, because fire is very architectonic or rather urban, above all in the countries of Northern Europe, where a lot of construction is done today in a more avant-garde manner than in the South, and because fire is the very symbol of social being and of society in general; and even more, because in Gelsenkirchen I learned that this very industrial city has long borne the surname of *"City of a Thousand Fires."*

I think that from the viewpoint of aesthetic perfection one can hardly debate the quality of fire. Fire is beautiful in itself, in whatever way....

With the three classical elements, fire, air, and water, the classical city of tomorrow will be built, flexible at last, spiritual and immaterial.

The idea in space, of using pure energy as a material with which to construct, no longer seems absurd in this way of thinking.

Gelsenkirchen, December 1958.

Fontaines et murs de feu.
"Fire Walls and Fire Fountains."
Gelsenkirchen Opera, 1958,
Collaboration Yves Klein - Werner
Ruhnau, Chalk on Paper,
Private Collection

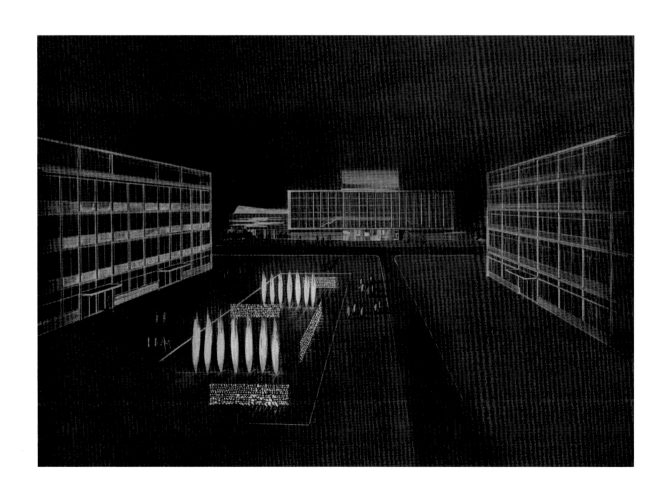

Immaterial Dwellings. Yves Klein.

I would now like to speak rapidly about a great architectural project that has always been close to my heart: The realization of a dwelling that is really immaterial but emotionally, technically, and functionally practical.

This house must be built with the help of a new material: air, blown into walls, partitions, roof and furniture. It must of course be possible to provide air conditioning so that the construction material itself can become the general and ambient heating and refrigeration of the whole house. All the foundations (basement, lower ground floor) of this house will, at most, reach no higher than ground level. These foundations will be built with solid material.

All the sheds, kitchen, bathroom, closets, etc.... This part of the house can be locked up, it will be underground. As for the rest it will not be necessary to provide any means of closing the house, for there will not be anything tangible to steal or take away.

In the garden or grounds, the pit, where the machinery is stored, must be quite far away, between fifty and one hundred meters, so that the noise of the machinery does not reach the house, and thus preserves its privacy.

In air, one builds with air (immaterial - material).

In the ground, one builds with soil (material - material).

For a whole city, the possibilities are more vast and interesting.

One single air roof may have a ventilating fan at one end to recover the air, while air sections delimit the spaces the huge roof hangs over.

Paris. April 14, 1959. Patents.
left to right, top to bottom:
"Création d'un toit d'air,"
"Mur de feu et d'eau Bungalow,"
"Maison atrium Toit d'air,"
"Projet pour une ville protegée,"
"Création d'un toit d'air,"

"Air Roof,"
"Fire and Water Wall Bungalow,"
"Atrium House Air Roof,"
"Sheltered City,"
"Air Roof,"
Blueball on Velum, 5"x8"
Private Collection

Antwerp. March 17, 1959.
Immaterial Work.
Group Show: "Vision in Motion,"
Hessenhuis.
"I pronounced in a loud voice these words borrowed from Gaston Bachelard: First there is nothing, then a deep nothing, then a blue depth." – Yves Klein

17

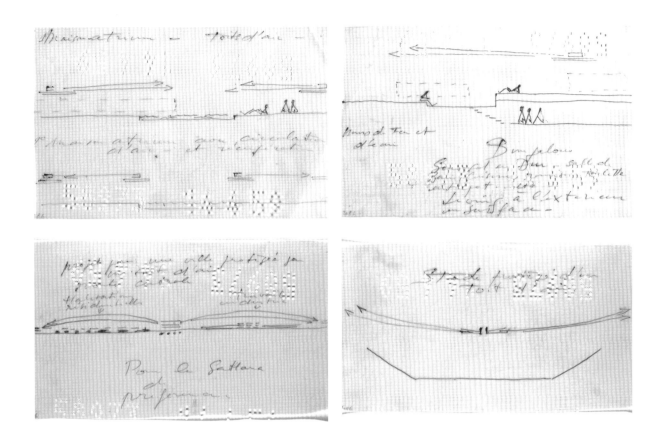

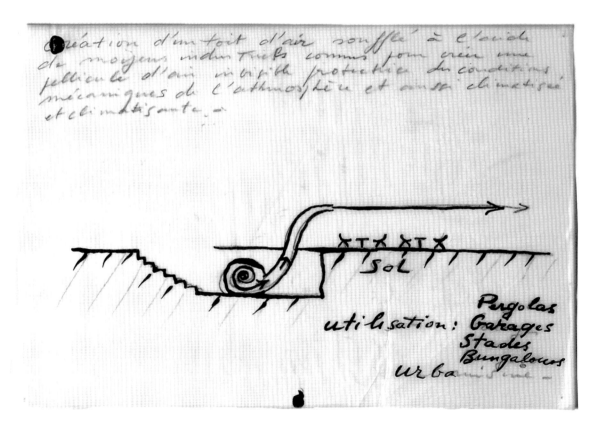

Paris. April 14, 1959. Patent
"Jets d'eau et de feu,"
"Fire and Water Jets"
Mixed on a Pool, 5"x8" Pencil on Velum,
Private Collection

It Is by Staying In One's Place
That One Can Be Everywhere. Yves Klein.

Until now, privileged habitation depended on temperate areas already privileged from the start.

The immaterial dwelling will be the establishment of privileged areas, the creation of microclimates anywhere.

...of nature in general on the surface of the globe is the aim we have in view, Werner Ruhnau and myself.

Traveling through space in missiles is, I maintain, an illusion, an illusion of conquering space, the static idea of building static solar mirrors in the stratosphere, or even in the void, is much more realistic. The conquest of space will indeed be achieved by restoring the legendary Eden, which will allow Man to be impregnated with sensibility in space. To realize this conquest of space, it is necessary to recreate the desert, the spirit of the desert. What is necessary is to bring about the impregnation of Man's sensibility in space.

Air Architecture is only a step on the way to immateriality in art.

Ruhnau and I spontaneously seized the problem of this non-problem of architecture in urbanism:

- the idea is living on the surface

- underground storage

- being free from all obstacles, the obstacle then acquires a plastic value, it is well defined, it becomes a luxury

- transformation of the material

- transformation of the former and still present conception of intimacy into a new intimacy, not psychological any more, a sort of constant awareness of space.

- destruction of the psychological family environment

- aerial forms borne on jets of air

- beds made of jets of air, on which one can lie in space

- optical fires

- jets of fire

- noise: the machinery is buried in the ground, far from the protected areas, the reservoirs of compressed air are constantly at the right level

Jets d'eau et de Feu
mêlés sur un Bassin
But Décoratif

O Feu
● EAU

Couronne de jets
d'eau pour magnor
l'indication du Brûleurs
Hauteur de 15 à 20 ...

Jets d'eau et de Feu
mêlés sur un Bassin
But décoratif

eau

Flammes

Les Brûleurs
sont des Brûleurs
ou Bi ... il doit
comme

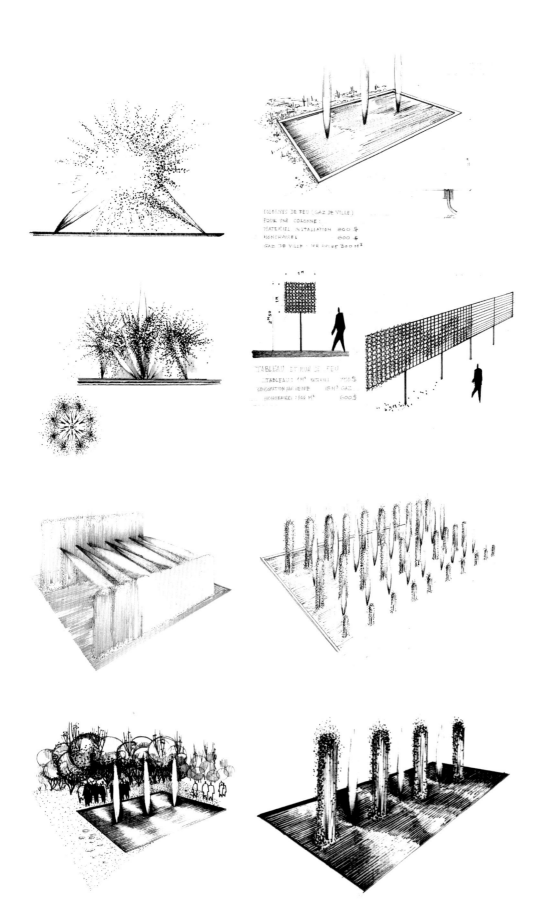

Paris. May 1959. Water and Fire Fountains.
Project with Architect Claude Parent
left to right, top to bottom:
"Mur de Feu,"
Fire Wall, Pencil on Paper 14"x41"
"Jets d'Eau et de Feu,"
Fire and Waterjets, Ink on Paper 12"x12"
"Jets d'Eau et de Feu,"
"Fontaines d'Eau et de Feu,"
"Colonne de Feu sur pièce d'Eau,"
Fire and Water Jets, Fire and Water Fountain, Fire Column on a Pool,
Ink on Paper, Various Dimensions
"Jets d'Eau et de Feu,"
Fire and Water Jets, Chalk on Paper 12"x19"

"Fontaine de Feu,"
Fire Fountain, Ink and Watercolor on Paper, 16"x17"
Private Collection

My walls of fire, my walls of water, like the roofs of air, are materials for the construction of a new architecture. With these three classical elements, fire, air and water, the city of tomorrow will be constructed, flexible at last, spiritual and immaterial. - Yves Klein

Paris. June 3, 1959.
The Evolution of Art Towards
the Immaterial,
Lecture at the Sorbonne.

18

19

20

The Evolution of Art Towards the Immaterial.
Lecture at the Sorbonne. Yves Klein.

First, I would like to return to Iris the title that she wanted to give me: The leader of our movement. I think she is the leader of our movement. She gathers us together in her gallery and stimulates our work and our research. [applause]

It seems that having now come to the facts, which Werner Ruhnau and myself are going to explain during these two lectures, this evening and Friday evening, I should leap back retrospectively, moving backwards along the diving board of my evolution without losing sight of the end I have consciously achieved, immaterialization in art, in order to bounce forward in one prodigious leap from the problematic of art to a genuine and true reality through sensibility the intelligent existence of which we think we defined such a long time ago, while remaining, in spite of ourselves, imprisoned by the psychological vertigo of composition, reaching the incommensurable prestige of life itself, where personality can not in any way imprint itself.

The architect, Werner Ruhnau, will lead us to the immaterial with a historical survey of architecture through the ages. As for myself, as a painter, I will try to bring you to the same immaterial through my personal experience combined with comments on the various actions that we will review, going backwards in time. What is the purpose of this retrospective journey into the past? Simply, I wish to avoid you or I, even for one instant, falling under the grip of that phenomenon of sentimental and landscaped dreams caused by a sudden landing in the past, precisely the psychological past which is counter space, the space from which I have been trying to escape for the past ten years.[1]

This work was unrewarding, laborious, and often accompanied by cruel doubts, yet it finally gave birth to the Architecture of the Air, which is already nearly a reality, achieved by Werner Ruhnau and myself, and which should, I hope, in the very near future, allow us to organize for our own total physical comfort the atmospheric and thermal phenomenon and circumstances of our globe.

First, calmly and coolly, I begin by seizing Arianes's thread, which for me is this impalpable sensibility, this new material, this new dimension, before entering the labyrinth of sensibility with the firm intention of never losing hold until I return. This is how it all happened.

In Antwerp, first of all, hardly two months ago, I was invited to an exhibition with a group of artists composed of Bury, Tinguely, Rot, Breer, Mack, Munari, Spoerri, Piene, Soto. I went to Antwerp and at the moment of the opening in the part of the exhibition gallery which was reserved for me at the Hessenhuis, instead of placing a painting or any tangible or visible object I spoke in a loud voice the following words borrowed from Gaston Bachelard: *"First there is nothing, then there is a deep nothing, then there is a blue depth."*[2]

21

The Belgian organizer of the exhibition then asked me where my work was. I answered, *"Here, here where I am speaking at this moment."*

"And what is the price of this work?"

"One kilo of gold, a one kilo pure gold bar will be enough for me."

"Why are you making such extravagant demands instead of asking a normal price simply represented by a sum of money?"

"Because according to pictorial sensibility as a raw material specialized and stabilized by me, these words spoken on my arrival, have made the blood of spatial sensibility flow: One cannot ask for money."

"The blood of sensibility is blue," says Shelley, and that is exactly my opinion. The price of blue blood can never be money, it must be gold. As we shall see later in Robert Desoilles's analysis of waking dreams, blue, gold, and pink are of the same nature. An exchange between either of the three can honestly be made.[3]

The public was very receptive; they were struck by a new value and were willing to follow but remained puzzled, waiting for something because they still could not see anything with their own eyes, neither a painting nor any sort of visual phenomenon. I decided to comment on my action and declared, *"You may seem to think that I am attempting to do something that is impossible, that I am plunging into something that is inhuman.... To tell you the truth, that is nearly what I would like. I mean I would like to begin my career as a painter by this action, but alas, all this is very human in the most genuine and constructive sense, in the most classical sense, because it is the result of a long evolution, a continual and persevering personal research, which was often very difficult over the years. A search for liberation, for an increasingly real comfort, more true and aerial than the material and tangible lives we live, stifled and obscured by technique that is the false and illusory view of science, whereas real science is pure art."*

I precisely wanted to reduce my pictorial action at this exhibition to the most extreme limits. I could have made some symbolic gestures, such as sweeping the space that was reserved for me in the exhibition gallery. I could even have painted the walls with a dry brush, without any color. No! These few words I have spoken are already too much. I should not have come at all and even my name should not have appeared on the catalogue. [*applause*]

"When technique fails, science begins," says Herschel. Tonight I can say with common sense that Man will never conquer space with rockets, sputniks or missiles because in this way he would remain a tourist in this space. But it is by inhabiting it through sensibility, that is to say, not by figuring in it but by becoming immersed in it, being embodied in life itself, which is the space ruled by the calm and formidable force of pure imagination and a feudal world, which like us, like Man, has never had a beginning or an end.

You must understand that I am not condemning technique, no, but let us leave it where it belongs. The more you live in the immaterial, the more you appreciate the material. Technique is a means; science, like art, is an end. Technique cannot in any way become a complete entity, or autonomous in the same way as a scientific fact or a work of art.

"Woe to the painting that shows nothing beyond the finite. The merit of a painting is the Indefinable, precisely that which escapes precision," writes Delacroix in his diary.[4]

At the opening of the exhibition of one of my friend's paintings last January, I spoke the following words concerning one of the problems Werner Ruhnau and I regard as having always been most important and human: cooperation in art. This short speech can be summed up as follows: Cooperating means combining our efforts with others with one aim in view and that aim is art. In art without problematic can be found the inexhaustible source by which, if we are real artists, liberated from the dreamy and pictur-esque domain of psychology, which is counter space belonging to the past, we will attain eternal life, immortality. Immortality can be gained together, this is one of the laws of nature and of Man in relation with the universe: In order to create, you must never look back to consider your work because you then come to a stop and that is death. The work of art must be like a volumetric furrow that penetrates by impregnating with sensibility the immaterial space of life itself.

In this joining of efforts we must therefore individually practice pure imagination. This imagination I am referring to is not a perception, the reminiscence of a perception, a familiar memory, the habit of colors and shapes. It has nothing to do with the five senses, with the sentimental or even purely fundamentally emotional domain. This is the imagination of the artists who can in no way participate because by trying to save their personality at all costs they kill their spiritual and fundamental self and lose their lives.

These artists who cannot cooperate work with their stomachs, their plexuses, and their bowels. The artists who can create together are those who work with their hearts and their heads. They are artists who know the responsibility of being a man is concerning the universe. For these artists, imagination is part of their way of thinking, the continual experience of opening up, the very experience of novelty as Gaston Bachelard says.[5] For these artists who are ready to cooperate, imagining means moving

away, rushing forward towards a new life. In their numerous endeavors in all directions and all dimensions, they are paradoxically both united and separated. Imagination for them is the audacity of sensibility.

What is sensibility? It is what exists beyond our inner self and yet still belongs to us. Life itself does not belong to us. It is with sensibility that does belong to us that we can buy it. Sensibility is the money of the universe, of space, of Great Nature, which allows us to buy life as a raw material.

Imagination is the vehicle of sensibility. Carried away by our imagination we reach life itself, life that is absolute art. In the furrow of such volumetric movements, with a static vertiginous speed, absolute art soon materializes and appears in the tangible world, that which mortals call, with a feeling of vertigo, *great art*.

I therefore invite all the artists who already know what I have been speaking about to create together, and even more, to scorn their possessive, selfish and egocentric personalities through a sort of exacerbating self assertion, in the tangible, physical, and ephemeral theatrical world, where they know very well that they are playing a part. I propose to each of them to go on saying *"my work"* regarding themselves, separately, when speaking to the living dead who surround us daily while we are at this work, which we have, however, achieved together. I suggest they continue to say joyfully *"my, I,"* etc. and not the hypocrisy of *"we"* and *"our,"* but only after having spiritually adhered to this idea of putting our means in common in the creation of a work of art.

I would then find it quite natural and normal to hear that one day one of the members of this agreement has suddenly and spontaneously signed one of my paintings somewhere around the world without even speaking of me or of what I have done. In the same way, I would hasten to sign any of the works that appeal to me among the members of this sort of pact without bothering in the least to point out that in fact it is not mine. [applause] I encourage them to take such extreme, apparently somewhat simplistic, naïve, and eccentric measures, maybe in order to show better how, in this cooperation I am proposing to adopt, we will have to consider with contempt the psychological, conventional world so that we can be really free.

It is not utopian to propose such a project. I am trying to reinstate on different foundations a perfect Bauhaus in 1959. I know all the facts concerning what I am speaking of. For one year already, I have successfully put it into practice with Werner Ruhnau, the architect. Together we have created Air Architecture and many other things, which are as yet in preparation. With the sculptor Norbert Kricke we have created, though not yet achieved, plastic elements of water, wind, fire, and light. With Jean Tinguely, for the past ten months, we have been digging together a mine full of constantly renewed wonder: the overwhelming fundamental static movement of the universe.

Next, I insist in particular on paying a special tribute to Iris Clert, in the name of all her *"foals"* as she calls us, for her high standards and enthusiasm regarding working together, for her magnetic genius as an organizer who in less than two years has managed to gather together, as I have already said, the most innovative, genuine, and determined artists of today.

Finally, by proposing to artists who work with their hearts and their heads to cooperate in art, I am proposing to go beyond art itself and seek individually a return to real life, where thinking man is no longer the center of the universe, it is the universe that is the center of Man. We will then experience prestige as opposed to the vertigo of the past, we will thus become men of the air. We will feel the force of attraction driving us upwards, towards space, towards nowhere and everywhere at the same time. Having thus controlled the force of attraction, we will literally levitate in a total and spiritual state of freedom.

I take this opportunity to answer to all sorts of present day pictorial endeavors called *"gesture," "sign,"* or *"speed."* I know an artist who has created painting machines of this type. These machines and the paintings they have produced will soon be exhibited in Paris. They are, as concerns a certain abstract or nonfigurative art, what the invention of photography was for nineteenth century realism. Just as the academic exacerbation of Realism was brought to an end by photography which, to my mind, allowed painting to return once again to a sense of wonder as it must always do precisely in order to be a painting, a work of art. This is how Impressionism came to be. In the same way, these extraordinary machines, which produce paintings whose quality, capacity to improvise, and variety are incredible and indisputable will, in this technical form of *"sign"* and *"speed,"* very fortunately put an end to the type of abstract art that for the past few years has led a whole generation to a void that has nothing in it, precisely to the moral calamity of the Western world: the hypertrophy of the Ego.

Concerning the artists who have often attacked my way of painting, I insist on saying that I am not interested in any sign when I navigate in the sea of sensibility. According to Poincaré, we could say that our sensations cannot give us the notion of space. This notion is constructed by our mind with pre-existing elements. The sensations in themselves have no spatial characteristic. *"You do not create speed by going fast,"* he states.

Descartes, whom all the fanatics of this art of gesture and sign condemn and despise, foresaw this technical device, which was to become a scientific object. These painting machines will soon be there, available to anybody who wishes to paint at any speed or in any lapse of time, limited or unlimited, with or without spirit, anger, delicacy, gentleness, and brutality. A good abstract painting, full of extraordinary signs produced by the extraordinary gestures of these machines, which are, moreover, spectacular to the highest degree. [applause]

Having said this I want to speak again about the attempts to coordinate among artists cooperating in view of an absolute art, attempts that today have not yet been easy to achieve. First of all, here is a general survey of the result of this research. It has to do with a manifesto published by Werner Ruhnau and myself, *The Creation of a Sensibility Center.* The task of this Sensibility Center is to reveal the potentialities of creative imagination as one of the forces of personal responsibility. A new conception, the real notion of quality must replace that of quantity, which is now worn out and over-evaluated. This can be achieved through immaterialization and sensibility.

The question now is to recognize that the problematic of art, religion, and science is obsolete. The problematic will no longer exist in the Sensibility Center. The idea of liberty will become a new notion thanks to limitless imagination and its various forms of spiritual realization. The universe is infinite but it is measurable. Pure imagination is attainable. It is viable. It must be experienced in the Sensibility Center. It will be the very core of its radiance. The immaterial architecture, which we are going to speak about this evening, will soon be the main facet of this Center. It will be flooded with light. Twenty professors and 300 students will work there without any syllabus, examination, or examiner. *[applause]* The action of Bauhaus Dessau did not depend on a space of time but on the concentration of ideas. Ten years later, the Sensibility Center can be abolished. In order to inspire in this Center a spirit of sensibility and of immaterialization, the professors must all, without exception, take part in the construction of the Center. All the students and trainees form an interplay of cooperation in this continually renewed construction. Materialism: All this quantitative spirit has been recognized as being the enemy of liberty. A battle has been waged for a long time against this way of thinking. The real enemies are psychology, acquired ways of seeing, sentimentality, composition, and sentimental heroism, which produce totalitarian worlds, spaces delimited by terror, remnants for the ventriloquists of the Western world. *[applause]*

This Sensibility Center requires imagination and immaterialization. It requires liberty regarding the heart and the head. As well as the creation of the Center, this program may, to my mind, have an influence on existing schools of art.

Then there is a list I am going to give you, even though it is very incomplete, of a few of the professors who have been approached:

Sculpture:	Tinguely
Painting:	Fontana, Piene, and myself
Architecture:	Frei Otto and Ruhnau
Theatre:	Polieri
Music:	Pierre Henry, Busotti

Photography:	Wilp
Criticism and History:	no one yet
Economy:	Péan
Public Relations:	Iris Clert *[applause]*
Religion, Press, Cinema, Television, Politics, Philosophy, Physics, Biochemistry:	no one yet
Martial Arts and War School:	General Dayan *[applause]*

The cost of the construction of this Center is estimated, in 1959, at $1.5 million:

The land:	$300,000
Annual expenses for twenty professors:	$1 million
Annual expenses for teaching material:	$100,000
The complete upkeep of 200 students a year:	$200,000

More than $1 million in expenses, accessories, and unforeseen costs to be spread over ten years.

The total sum of $15.8 million is necessary for this Center to exist over a period of ten years, which is really very little compared to what is spent to visit outer space in the fiction-minded outlook of the nineteenth century. *[applause]*

Going prudently and progressively back in time, we now come to April 1958 with the preparation and presentation in the Iris Clert gallery of the exhibition, *The Specialization of Sensibility in the Raw Material State into Stabilized Pictorial Sensibility.* This manner was called my *"Pneumatic period."* *[laughter]* According to the ethical standards I have laid down for myself over the past ten years, ethics that led to this immaterialism and will allow us to rediscover a real love of the material as opposed to quantitativism, to materialism that fossilizes us and makes us slaves of this material, which it changes into a tyrant.

Through this endeavor I wish to create and present to the public a sensible pictorial state within the limits of an exhibition gallery for ordinary paintings. In other words, create an ambience, a pictorial climate, which is invisible but present in the spirit of what Delacroix in his journal calls *"the undefinable,"* which he considers as the very essence of painting.

This pictorial, invisible state in the space of the gallery should, in every way, be the best definition of painting in general that has been given so far, which is radiance. This invisible and intangible immaterialization of the painting should act much more effectively, if the creative operation is successful, on the vehicles or sensible bodies of the visitors to the exhibition than ordinary, visible habitual, representative paintings whether they are figurative or non-figurative or even monochrome. *[laughter]* Obviously, if these are good paintings they are endowed with a

particular pictorial essence. This affective presence, in a word, with sensibility is transmitted by the suggestion of the whole physical and psychological appearance of the painting: lines, contours, composition, opposition of colors, etc.

At present, there should no longer be any intermediaries. One should be literally impregnated by the pictorial atmosphere, which has been already specialized and stabilized by the painter in the given space. It must then be a matter of direct and immediate perception-assimilation without any more effect or trick beyond the five senses in the field that is common to man and space: *sensibility*.

How can this be achieved? I shut myself up alone in the gallery, forty-eight hours before the opening, in order to repaint it entirely in white. I do this on the one hand to clean it of the impregnations of the numerous preceding exhibitions. *[laughter]* On the other hand, through my action of painting the walls in white, the non-color, I make it for a moment my space of work and creation, my studio.

Thus I think that the pictorial state that I have already been able to stabilize in front of and around my monochrome paintings will now be well established in the space of the gallery. My active presence in the given space will create the climate and the pictorial ambience that usually reigns in the studio of an artist endowed with real power. A sensible but real abstract density will live by itself and for itself in spaces that are empty in appearance only.

In short, I do not wish to go on speaking at length about this exhibition. I must simply say that the experience was decisive and made me deeply understand that painting is not a function of the eye. It was a complete success, and the popular press was obliged to record this phenomenon and that it had observed that forty percent of the public polled were seized by something that was certainly very effective in this small and apparently empty exhibition room, for many people were furious when they entered, and satisfied when they came out. *[laughter]* They commented and discussed in a serious and positive way the real possibilities of such a demonstration. I think I must also say that I even saw many people go in and, a few seconds later, either burst into tears for no apparent reason or begin to tremble, or even sit down on the floor and stay there for hours on end without moving or speaking. *[laughter, applause]* I must confess that all this amazed me a great deal and still amazes me as much today. *[laughter]* How did I come to this state of mind? Very simply, because when you have undertaken something, it is always pleasant to follow it to its conclusion. *[laughter]* And we shall see later, when concluding on Air Architecture, that I was not wrong in acting in this way, although for a long time everything seemed to show that I was venturing towards a dead end. Phantoms and strange characters

belonging to nobody came out of this void filled with sensibility, such as these pictorial sponge sculptures and portraits of the beholders of my monochromes.

But let us now go back to my *"blue period"* in 1957. It made me discover that my paintings are only the ashes of my art. I exhibited these blue monochrome paintings, all identical, same color and same size, at the Iris Clert and Colette Allendy galleries. Quite passionate controversies arising from this demonstration proved to me the value of this phenomenon and how deeply it affects men of good will who do not at all care to be passively subjected to recognized concepts and established rules.

Each of these blue monochrome propositions, all similar in appearance, were recognized by the public as being each quite different from the other. The art lover went from one to the other just as it should be and, in a state of instantaneous contemplation, penetrated into the world of blue. *[laughter]* The most amazing observation was that the buyers each chose their own among the eleven paintings exhibited and paid the price they were asked. The prices were all different of course. *[laughter]* Which goes to show that the pictorial quality of each painting can be perceived by something other than its material or physical appearance. Those who chose were conscious of this state of things, which I call *pictorial sensibility*.

Why did I come to this blue period? Because before that, in 1956 and 1955, at the Colette Allendy gallery I exhibited about twenty monochrome surfaces, all in different colors: green, red, yellow, violet, blue, and orange. This is how I happened to adopt this manner, at the beginning of my career, or at least how I started to present it to the public. I was trying to show *"color"* and at the opening of the exhibition I realized that the public, in front of all these different colored surfaces that were exhibited, was imprisoned by an acquired way of thinking and consequently they reconstructed the elements of a decorative polychrome painting. They could not penetrate into the contemplation of the color of one painting at a time and this is very disappointing for me precisely because I categorically refuse to make use of even two colors at a time on the same surface. To my mind, two colors opposed on the same canvas do not allow the viewer to feel the dominant, the sensibility, the pictorial intention, but force him to witness either a battle between these two colors or their perfect harmony. It is a psychological, sentimental, and emotional situation, which perpetuates a sort of reign of cruelty, *[laughter]* so that one can no longer be immersed in sensibility and pure color delivered from all exterior contaminants.

It may be objected that this evolution was very rapid, hardly four years, and that nothing can be done in such a short time, it reveals too much facility and consequently the lack of deep and real values in this endeavor. I will answer that, in fact, I only

started to exhibit my paintings in 1954, in Paris, but I had already been working in this manner for a long time, since 1946. This long period of waiting precisely shows that I learned to be patient and to wait. [laughter]

I waited until this was stabilized within me in order to show it and demonstrate it. The few friends who encouraged me at that time know this well. I had come to paint monochromes alongside my normal pictorial activities, which came to me from the influence of my parents who were both painters, because it seemed to me that color was continually winking at me when I was at work. On the other hand it filled me with wonder because in front of any painting, whether figurative or non-figurative, I felt more and more as if the lines and all their consequences, forms, perspective, and composition were very precisely shaped into the bars of a prison window. In the distance, color, life and freedom, and myself in front of the painting, I felt imprisoned. I think that it is because of the same feeling of imprisonment that Van Gogh exclaimed, *"I would like to be delivered from this horrible cage that I cannot describe!"* And later, *"The painter of the future will be a colorist as we have never seen before."*[6] This was to come about one generation later.

It was therefore indeed through color that I became acquainted with the immaterial. The outside influences, which led me to persevere in this monochrome manner until I reached the immaterial, as I have today, are numerous. By reading the journal of Delacroix, the champion of color and the instigator of contemporary lyrical painting, and then by comparing the position of Delacroix to that of Ingres the champion of academicism, which engenders the line and all its consequences and has led to the art of today. Then to the exacerbation of the line, as can be seen in the fine, great, and dramatic adventure of Malevich, or also, concerning Mondrian, the totally insoluble problem of the organization of space, which has produced polychrome architecture, which our present day urbanism suffers from so cruelly.

Finally and above all I received a great shock in Assisi, in the Basilica of Saint Francis, when I discovered that the frescoes were scrupulously monochrome, blue and of one color, which I believe I can attribute to Giotto but could be by one of his students, by a disciple of Cimabue or even one of the artists of the Sienna School. Although the blue I am speaking of is very much of the same nature and quality as the blue of the sky in Giotto's paintings, which can be admired in the same basilica on the upper level. Even if Giotto only had the figurative intention of showing the pure blue and cloudless sky, nevertheless the intention was to paint in a monochrome manner.

Unfortunately, I only had the pleasure of discovering the works of Gaston Bachelard very late, last year in the month of April 1958. I wish to answer the question often put to me, Why did I choose blue? by quoting once again Gaston Bachelard in one of the

wonderful passages from his book concerning blue: *"First, a document taken from Mallarmé in which the poet, living in the 'dear ennui' of Lethean lakes, suffers from the irony of the azure. He perceives an azure that is too offensive and wants to stop with untiring hand the great blue holes naughtily made by birds. It is through this activity of the image that his human psyche receives future causality through a kind of immediate finality."*[7]

He continues:

"Other materials harden objects. Also in the realm of blue air more than elsewhere we feel that the world may be permeated by the most indeterminate reverie. This is when reverie really has depth. The blue sky opens up in depth beneath the dream. The dreams are not limited to one-dimensional images. Paradoxically, the aerial dream soon has only a depth dimension. The other two dimensions, in which picturesque, colored reverie plays its games, lose all their oniric interest. The world is then truly on the other side of the un-silvered mirror. There is an imaginary beyond, a pure beyond, one without a within."

And then comes the wonderful sentence: *"First there is nothing, then there is a deep nothing, then there is a blue depth."*[8] This is the quotation I used in my Antwerp speech.

For Claudel, blue is obscurity become visible. That is precisely why Claudel can write, *"Azure between day and night, shows a balance, as is proved by the subtle moment when, in the Eastern sky, a navigator sees the stars disappear all at once."* Blue does not have any dimension, it is outside any dimension, whereas other colors do have one. They are psychological spaces. Red, for example, presupposes heat coming from a hearth. All the colors arouse concrete, material, or tangible associations of ideas in a psychological manner, whereas blue, at most, recalls the sea and the sky, which, after all, is what is most abstract in tangible and visible nature.

Concerning these commentaries on blue, I would like to speak of Robert Desoille's waking dream, which can testify to the immaterializing value of pure imagination: *"Imagination and will are two aspects of a single profound force. Anyone who can imagine, can will. To the imagination that informs our will is coupled a will to imagine, a will to live what is imagined."*[9] Therefore, let us follow Robert Desoille's apparently simple method. Desoille counsels the subject who is bothered by a specific concern to put it with all the others in the rag picker's bag, in the sack he carries behind his back. This is in keeping with the very expressive and effective gesture of the hand that throws everything it scorns behind its back.

It must not be forgotten that *"we are dealing with psyches that cannot decide to make up their minds and who do not listen to rational rebukes…. When the spirit has thus been somewhat*

prepared for freedom, when it has been unburdened of terrestrial cares, then its training in imaginary ascension can begin." [10]

Desoille then suggests to his patient that he imagine himself walking up a gently sloping path, with no abysses, no vertigo. Perhaps he could be helped gently here by the rhythm of his gait, feeling the dialectics of the past and future that Crevel pointed out so well: *"One of my feet is called past, the other future."* [11]

We must come back to *"the directed ascensional dream"* upon which I would like to focus now.[12]

As a matter of fact, Desoille's method takes into account a sort of ascension in color. It seems that an azure, or sometimes a golden color, appears on the heights, which we ascend in dreams. Often without any suggestion, the dreamer, as he is living this imaginary ascent, will reach a luminous place where he perceives light in a luminous form. Luminous air and aerial light, in a reversal from substantive to adjective, are joined in one material:

The dreamer has the impression of bathing in a light that carries him. He actualizes the synthesis of lightness and clarity. He is conscious of being freed both from the weight and the darkness of his flesh. In certain dreams there is a possibility of classifying ascents as being ascents into either azure or golden air. More precisely there should be a distinction between ascents in gold and blue and those in blue and gold, according to the dream's color of transformation. In all cases the color is volumetric, happiness pervades the whole being.[13]

This universal light engulfs and blurs objects, little by little. It makes contours lose their sharp lines. It obliterates the picturesque in favor of the radiant. At the same time, it rids dreams of all the *"psychological what not"* that the poet mentions. Thus it gives *"a feeling of serene unity to the contemplative person."*

Desoille's method, then, is an integration of sublimation into normal psychic life. This integration is facilitated by images of aerial imagination.

An initial calm is replaced by a conscious calm, the calm of heights, the calm from which one sees from 'on high' the turmoil down below. Then a pride is born in our sense of morality, in our sublimation, and in our life's story. That is when a subject can allow his memories to rise up spontaneously. Memories have a better chance at this stage of being more meaningful, of revealing their causality, since the conscious dreamer is, in a certain sense, at a high point in his life. His past life can be judged from a new point of view, one that we might almost say is absolute: The person can judge himself. The subject often realizes that he has acquired new knowledge, has just become psychologically lucid.[14]

Precisely.

Although I think it is now necessary to return to the present day to introduce you to Air Architecture, I must also speak to you about fire and water, a non-architecture, which I want to integrate to this constantly evolving architecture.

Fire, for me, is the future without forgetting the past. It is the memory of nature. The project for a public square with a pool where jets of fire would dance instead of jets of water and building firewalls in Air Architecture, is an idea, which goes back to 1951. I was in rapture at the Granja, a summer palace of the Spanish monarchy, some eighty kilometers from Madrid, looking at the water fountains and jets in the gardens, similar in every way to those of Versailles. That is where I imagined replacing the tranquil surface of these pools, the elegant jets of water with brilliant jets of fire. Fire sculptures on the water...why not? The functional-psychological goal of water jets on stretches of water is to bring a general coolness or, at least, a sensation of coolness. For countries with a less favorable climate, where the cold reigns for quite a long time in the winter, it is a luxury to present jets of water. Whereas it is quite functional and also aesthetic and psychological to present jets of fire on a spatial water mirror base, which forms an invisible, impassable barrier. *Fire is sweetness, fire is sweetness and torture. It is cuisine and apocalypse. It is pleasure for the child sitting quietly by the hearth, yet it punishes any disobedience when one seeks to play too closely with its flames. It is well-being and it is respect. It is a tutelary and terrible god, good and bad. It can contradict itself, thus it is one of the universal principles of explanation.... It has never perhaps been sufficiently noticed that fire is a social being rather than a natural being. To see the justification of this remark, there is no need to develop considerations on the role of fire in primitive societies, nor to insist on the technical difficulties of the maintenance of fire, it is enough to deal in positive psychology, examining the structure and education of a civilized mind. In brief, the respect of fire is a learned respect, it is not a natural respect. The reflex that makes us draw our finger away from the flame of a candle does not play any conscious role in our knowledge.*[15]

On the other hand, I do not think that from the viewpoint of aesthetic perfection one can question the quality of fire. Fire is beautiful in itself, in whatever way.

As for these walls of fire, further on in my speech you will probably understand very well how they will be adapted to Air Architecture.

As for the edification of walls of water against the walls of fire, one must also speak of water in itself in order to understand fully the spirit of water. It seems that silence must first be understood in

relation to our soul, which needs to see something become silent. *"And as in ancient times, you could sleep in the sea,"* said Paul Eluard in *Necessités de la vie*.[16]

The hymn delivered by Saint Yves continues thus: *"Ambrosia is in the waters, oh waters bring to perfection all the remedies which chase away illnesses so that my body will feel your good effects so that I may see the sun for a long time yet."*[17] Also one must not forget the spirit that hovers over the water. It is the fluidic element, the essential feminine element, which we need in order to establish the balance between justice and violence.

The return to Eden after the fall of Man is well on its way; we have gone through a long evolution in history and reached the height of perspective and the failure of the Renaissance through the psychological vision of life. Today this evolution comes to us through dematerialization leading to immaterialization, and we are happily moving towards a genuine and dynamically cosmic well being. Of course it is not enough to say, to write, or to proclaim, *"I have overcome the problematic of art!"* One must also have done it, as I think I have done. For a moment I would like to switch to overcoming the barrier of technique; it is a method that has always come from this personal ethic of which I have already spoken and has allowed me, as a painter, to settle in unknown domains without any difficulty other than the usual technical difficulties met anyway by the most well-informed technicians themselves.

For thousands of years, Orientals have cultivated a sort of hierarchical ritual, which, for example, allows a corporation to attribute to the member of another corporation a rank whose quality is equivalent. I observed this in Japan during a training course lasting a year and a half at the Imperial School of Ancient Martial Arts. In Judo the council of the highly ranked members often spontaneously attribute a high rank, honorary of course, to a brilliant scientist, for example, who hardly practiced any judo at college when he was young. Nevertheless, this rank is respected without hesitation by all the members of this corporation.

We in the West must change this hierarchical ritual into an effective dynamic reality. Thus, I want to give you an example of my capacity to move into the field of music.

A few years ago I created *The Monotone Symphony*, of which this is an extract: [*sound*]. Now a scream by François Dufrêne, a monotone scream: [*a scream, applause*]. Now a scream, listen carefully, a scream by Charles Etienne: [*a scream, laughter*]. And now a very fine scream by Antonin Artaud: [*a scream*].

I am sorry that I cannot give you an extract from the symphony by Pierre Henry, the well-known composer of concrete and phonic music, but my tape recorder does not work at the same speed.

Yes, indeed, but it is too difficult to put it right just now. However, it is precisely the same symphony as the one I composed a few years ago, from which you heard the extract at the beginning and was reconstructed by Pierre Henry in a, eh, much more competent way. [*laughter*]

This extract from my *Monotone Symphony*, which you listened to at the beginning, is an electronic sound. Originally, the *Symphony* lasted forty minutes. [*laughter*] It precisely lasted that length of time to show the desire to overcome time. The attack and end had been cut out which created a strange sound phenomenon that whirls up sensibility. Indeed, this *Symphony*, which had not the slightest perceptible beginning or end, was outside the phenomenology of time. It had no relation with the past, the present, or the future since, after all, it had never been born nor had it ever died, after having existed, however, in the physical reality of sound.

Therefore, in order to come back to the idea of overcoming my art, I am preparing a big concert in this monotone spirit but this time it will no longer be electronic. I find it too cold. I want to personally direct a large classical orchestra composed of 150 performers. [*applause*]

At present it would take too much time to go into the details of this project. The idea, which can be derived from this and is related to the subject we are dealing with today, is this possibility that the artist of the Western world, in the spirit of the pure classical fugue, must look for in order to escape from the melody and rhythm, so that the subject is his sole theme and he abolishes the counter subject, which will never reappear. There will no longer be any exposition or episode or development, it is the future canon of the classical fugue transposed into an immediate theme.

I wish to express to you my surprise when I observe what a paltry idea one has in Europe concerning Japanese calligraphy. These poor people who are concerned with gestures and signs have only understood its exotic and superficial aspect. One does not know or one seems to refuse to admit that Japanese calligraphy has in fact developed in this way. [*applause*] Take note of this, it is true, I am not joking [*laughter*], that is how it happens. Anyway, it is too much! I want to yell to these painters-Action painters, etc.- Stop gesticulating like this! It is not because you move about like mad men that you are active! If only you could return today, thanks to those terrible machines I have already spoken of, to real art, just as the Impressionists in their time rejected the cruel reality of the objects of Courbet's realism, through the invention of photography and the wonder of life and life in itself. May you be delivered from the torments, which, to my mind, torture you in the hell where composition, speed of lines and shapes do not lead you anywhere.

To my mind, art is not a language or a possibility of communicating for artists. If it were so, a work of art would only be a means and not an end, a real creation. Man alone creates a work of art so that he will no longer be alone, for there may be only one man on the whole of the earth but there may be several works of art. The artists of the twentieth century must bring about their integration in society and stop being strange people. Before concluding, I will have the pleasure of trying to place once again, my ethics, for a moment, in the problematic of economy and in the social structure, so that it will be in direct relation with immaterial architecture and urbanism.

How can I do this drawing from the pictorial that I have constructed? In order to paint, I spent a long time searching for a fixative medium, precisely to fix these grains of pigment, which create a radiating and dazzling mass when the pigment is only a powder in the drawers of the color dealer. It is dismaying to see that the same pigment, once it is ground with oil, for example, loses all its radiance, all its own life. It then seems to be mummified and yet it cannot be left on the ground under the effect of the fixative medium, which is the invisible force of attraction of the earth, because man is naturally in a standing position and looks at the horizon. The painting must be presented perpendicular to the ground like a screen. The pigment must therefore be stuck in some way or other to the support. I looked for a fixative medium that could fix every grain of pigment between one another then onto the support, without any of them being spoilt or deprived of their own capacities to radiate, while being united with the others and with the support, thus creating a colored mass, a pictorial surface.

This is how, by applying the standards of pictorial research to the whole population of any country, with the idea of presenting one day a painting which will radiate in the gallery of the world, visible to the universe, we realize that the monetary system, money, is the fixative medium of all the individuals grouped in a society [laughter]. It mummifies them, takes away their authority over themselves and leads them straight to quantitative overproduction instead of bringing them together and at the same time leaving them their free and imaginative responsibility, which forces them to find their well being in qualitative production.

Thus, the outline of a technical manifesto in order to try and transform the community can be summed up in the following way: Change the way of thinking and acting of a population through a qualitative sense of individual duty towards the national community and a qualitative sense of national duty towards the community of nations. In this way, a whole nation could be raised to an aristocratic pride in its moral standards on an individual scale, truly integrated in society. Thus, an outline of the economic system can be summed up in the following way: Economy is the favorite domain of vain illusions and constructions where prejudice reveals a lack of acolyse - eh, I mean - *analysis* beforehand. Some schools of thought believed they could perceive quite a number of realities. However, such an approach of economic facts too often remained an approximation. Such down-to-earth physiocrats, while they exhausted the outer layer of the sensible universe, were not able to unload the materiality of the cosmos to finally reach the definition of knowledge by becoming aware of the marginal use of space. A new attempt appeared in the thirties with the Keynesian School and the theory known as the *Theory of Full Employment.* But if the cause of full employment could lead to a therapy, which after all can be considered as valid, total ignorance regarding a collective consciousness of spatial reality could, once again only lead to quantitative approximation. Thus, it can be seen that everything can be analyzed in terms of bankruptcy, and the balance sheet of compound economy today can only predict an important deficit. A new era should come about where a qualitative perception of the field of energy could at last orient the fundamental inertia of the living thing towards a dynamic conception of the created thing.

To my mind this conception is founded on the elaborate wealth increasing daily. Thus appears a long fresco, which awaits its monetary guarantee. Indeed, I object to monetary reserves, currencies, the accumulated riches of past splendor, which nevertheless perilously mortgage present structures. From now on, no need for these costly intermediaries whose sham values increase the past gap between intellectual understanding and the very quality of the values that have been gained. Let us now simply look at the intrinsic value of the material, which resides essentially in the notion of quality, and, on this structurally qualitative level, each corporation would be obliged to leave in the cellars of the Central Bank, formerly rid of any metal deposit, the masterpiece of their profession. These masterpieces thus gathered together would materialize the fundamental spiritual orientation of the country, leaving a free access to any potential evolution, which is the only source of progress.

This permanent example, which is the catalyst of latent powers, by maintaining in one's mind a stable sample open to change would at last allow the establishment of the foundation for a fundamentally healthy system based on exchanges free from conjectural quantitative variations. Finally, the suppression of fiduciary circulation could, at the same time, suppress the slightest possibility of a cyclic development producing the classical inflationary spiral. Overproduction, instead of introducing a useless increase in quantitatively countable wealth, would no longer be a pure and simple loss of strength but on the contrary a general emulation, this constructive endeavor would lead to the splendors of the future. On the international level, the creation of a standard representing a spiritual value would avoid the development of any sort of commercial Malthusianism and

would bring about the end of tariff barriers, this idea of quality would have a multiplying effect on formerly antagonistic national economic systems.

These brief introductions on what the economy of tomorrow could be, if we wished it to be so, give a glimpse of the huge possibilities of a system that would at last conciliate the universal intellectual and moral aspirations with the most peremptory economic demands. In such a system a rich man would necessarily be a genuine genius in his field. This would only be fair, after all.

But let us forget these propositions, which are too strict and too severe, and return to the possibility of applying once again this sort of ethics, for example, to the theater. Gradually, we come to a performance without actors, without any scenery, without a stage, without any spectators, nothing left but the creator alone, not seen by anybody except the presence of nobody and the show begins. [applause] The author experiences his performance, his creation, he is his own public and his own triumph or disaster. Little by little, the author no longer belongs to himself and yet the show goes on. To experience a constant performance, a constant manifestation, to be there, everywhere, within as well as without, to enjoy life as a raw material, a sort of sublimation of desire, a material saturated and impregnated in the *"everywhere"* and the show goes on, a *"mono"* show, at last outside the psychological world. The show of the future in an empty theater.

Therefore, this is how, through all the research we carried out concerning art moving towards immaterialization, Werner Ruhnau and I met on the subject of Air Architecture. He felt embarrassed by the last obstacle, which even someone like Mies van der Rohe has not yet been able to overcome: the roof, the screen that separates us from the sky, the blue of the sky. As for myself, I was embarrassed by the screen constituted by the tangible blue on the canvas, which deprives one of the constant vision of the horizon.

A few years ago, I had already dreamed of this conception of Air Architecture in my monochrome endeavor but without understanding all its considerable importance and impact. Werner Ruhnau has succeeded in developing and making a reality of this idea, which, I confess, was vague. Man in the Garden of Eden, in the Bible, was, no doubt, in a state of static trance, as in a dream. The man of the future, by integrating total space, by taking part in the life of the universe, which will constitute the first step towards Air Architecture, will, no doubt, be in a state of dynamic day dreaming with an acute consciousness concerning tangible, material, and visible nature, which he will control, on a terrestrial level, for his own physical comfort. Liberated from the false interpretation of psychological intimacy, he will live in a state of absolute with nature (which is invisible and cannot be perceived

by our senses), with life itself, which will have become concrete by a reversal of roles...abstraction being created by psychological nature. Please forgive me.

To conclude, here is the exact text of our Air Architecture manifesto. First, blue light as a building material corresponds to void: Energy must be used in the stratosphere; in the atmosphere, heavy air or any other gas that is heavier or more dense than air will be used as building material, also using optical fire effects, magnetism, light, and sound. Sound will be used against sound in order to neutralize it. On the ground, mortar, concrete, stone, clay, and iron will of course be used as building material.

Air architectures are only presented as examples. Finally, what is important is the spiritual principle itself of using new material for a dynamic architecture. Air, gas, fire, sound, odors, magnetic forces, electricity, electronics are materials. They must have two main functions, namely: to protect against the rain, the wind, and atmospheric conditions in general, and create thermal air conditioning. It is possible to consider separating the two functions. It is proved that certain construction elements correspond to each original state of nature, such as earth, water, and air. These construction elements must always be more dense and heavy than the original state in which we use them.

Air architectures must be adapted to the natural conditions and situations, to the mountain, valleys, monsoons, etc., if possible without requiring the use of great artificial modifications. For example, in a place where the wind changes its direction every six months, the *"air roof"* can be created with very little artificial help. Finally, it is the ancient dream of men and of the imagination to make use of the elements of nature to order and control their phenomenon and manifestations.

In my development, I was to come to Air Architecture, because only there could I at last produce and stabilize pictorial sensibility in a raw material state. Until now, in a very precise architectonic space, I have been painting monochromes in the most enlightened manner possible. Color sensibility, which is still very material, must be reduced to an immaterial, more pneumatic sensibility.

As for Werner Ruhnau, he is certain that the architecture of today is on its way towards the immaterialization of the cities of tomorrow. The suspended roof and tent constructions by Frei Otto and others are important steps in this direction. By using air, gases, and sound as elements of architecture, this development can be carried yet further. My walls of fire and my walls of water are, with the roofs of air, materials for a new architecture. With these three classical elements, fire, air, and water, the city of tomorrow will be constructed; it will at last be flexible, spiritual, and immaterial. For men, the idea of using pure energy to

construct in space no longer seems absurd from that point of view. In such a conception of architecture, it seems easy to understand that the disappearance of the picturesque and painted reverie is inevitable and fortunately so, because it is the picturesque that has killed all the real powers of Man.

I wish to end by paying homage to Werner Ruhnau with this poem by the great German poet, Christian Morgenstern.[18] Please forgive me for the bad translation:

The Picket Fence

One time there was a picket fence
with space to gaze from hence to thence.
An architect who saw this sight
approached it suddenly one night,
removed the spaces from the fence,
and built of them a residence.
The picket fence stood there dumbfounded
with pickets wholly unsurrounded,
a view so loathsome and obscene,
the Senate had to intervene.
The architect, however, flew
to Afri- or Americoo.

These are the words of the poet. [*applause*]

Werner Ruhnau will probably not have to escape or at least I hope not. For I think that Europe, as part of the Western world, will understand in time the value of our endeavor to immaterialize in order to live without delay in *the virginity, the vivacity, the beauty of today.*[19]

[*applause*]

Paris, June 3, 1959.

Notes.

1 Bachelard, Gaston. "L'air et les songes," ("Air and Dreams"), Paris, Librairie José Corti, 1943

2 Ibid.

3 Robert Desoille, psychotherapist (1890-1966)

4 Eugène Delacroix, painter (1798-1863)

5 Bachelard, "Air and Dreams."

6 Vincent Van Gogh, painter (1853-1890)

7 Bachelard, "Air and Dreams."

8 Ibid.

9 Ibid.

10 Ibid.

11 Ibid.

12 Ibid.

13 Ibid.

14 Ibid.

15 Bachelard, Gaston. "La psychanalyse du feu," ("Psychoanalysis of fire"), Paris, Editions Gallimard, 1949

16 Bachelard, Gaston. "L'eau et les rêves," ("Water and Dreams"), Paris, Librairie José Corti, 1942

17 Ibid.

18 Christian Morgenstern, poet (1871-1914)

19 Stephane Mallarmé, poet (1842-1898)

22

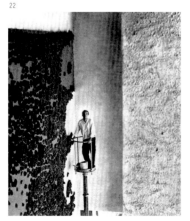

23

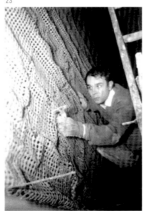

24

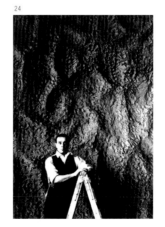

Gelsenkirchen. December 15, 1959.
Yves Klein working on the Gelsenkirchen
murals. Blue monochromes and Sponge
Reliefs, Gelsenkirchen Theater, 1959,
various dimensions

25

26

Paris. February 17, 1960.
Yves Klein and a model making Anthropometry,
14, rue Campagne-Première, Paris.

27

28

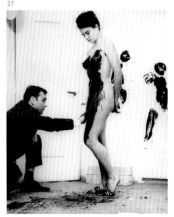
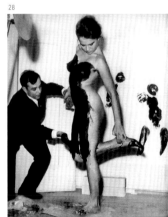

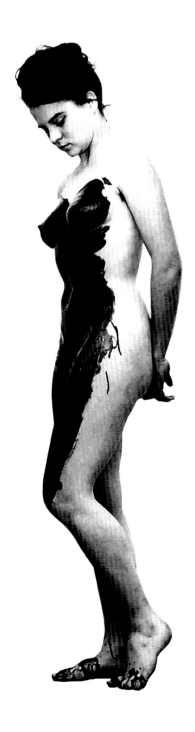

Symphonie Monoton Silence.
"Monotone Silence Symphony,"
Hand scored musical staff paper

Paris, March 9, 1960.
"Anthropometry of the Blue Period
and Monotone Symphony"
Galerie internationale d'art
contemporain, Paris

29

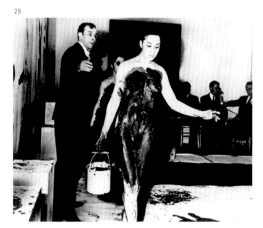

30

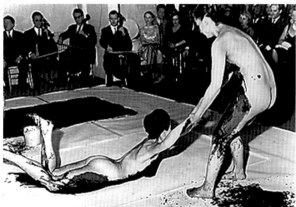

Yves Klein

Symphonie - "Monoton-Silence"

1947 --- 1961

Durée: 5 ou 7 minutes
Plus 44 secondes de
Silence absolu.

Pour Orchestre
interprétation très Vive
et très continue.

3 Fl.

3 ob.

3 Co.
(in fa)

S

A

T

B

V

Vc

CB

Composition de
d'Orchestre

20 Chanteurs
10 Violons
10 Violoncelles
3 Flûtes
3 Hautbois
3 Cors
3 contrebasses

"Cosmogonie pluie," (COS 22).
"Rain Cosmogony,"
1961, Color Pigment on paper, 28"x39"
Private Collection

Nice. June 23, 1960.
Yves Klein creating "Cosmogenies" on
the river bank Loup near Nice.

31

32

"Vent Paris-Nice," (COS 10). >
"Wind Paris-Nice,"
1960, Color Pigment on Paper, 37"x29"
Private Collection

Paris-Nice. Summer 1960.
During a trip to Nice Klein strapped a
canvas on the roof of his DS Citroen to
record the memory of the wind

33

Paris. October 23, 1960. "Saut dans le Vide."
"Leap into the Void,"
Photographs by Harry Shunk,
Private Collection

34

35

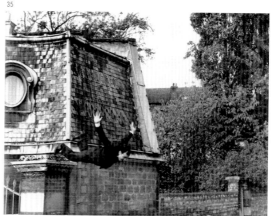

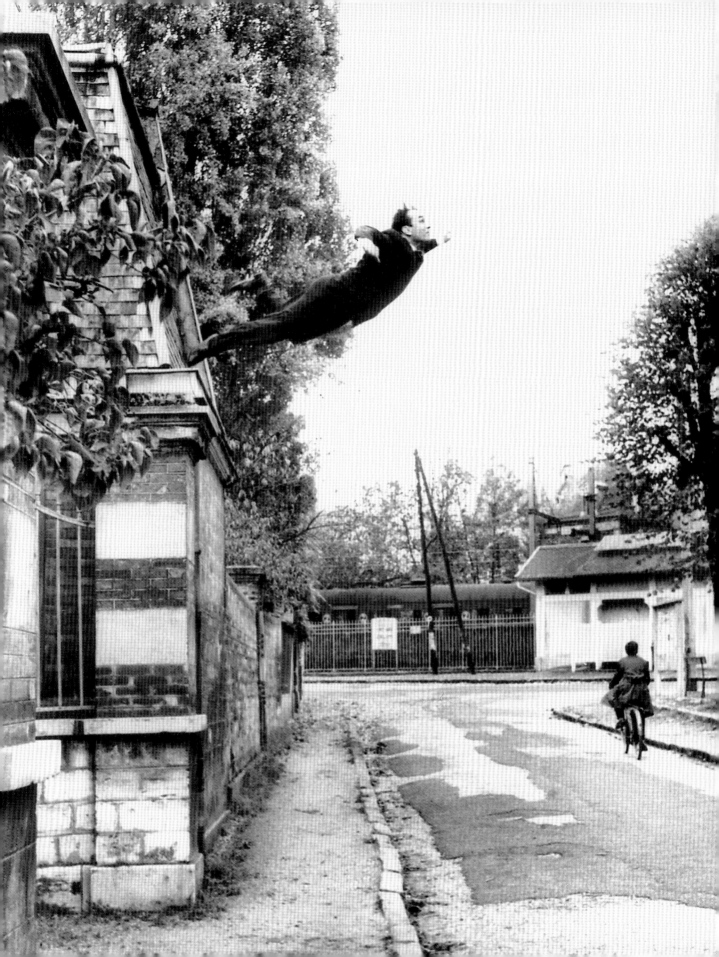

Paris. "Dimanche 27 novembre 1960. Le journal d'un seul jour."
"Sunday, The Newspaper of a Single Day,"
Four pages illustrated newspaper, written and designed by Klein,
Private Collection

37

La Révolution bleue continue

SEANCE DE 0 HEURE A 24 HEURES

Dimanche

27 NOVEMBRE

0,35 NF (35 fr.) — Algérie : 0,30 NF (30 fr.) - Tunisie : 27 mil.
Maroc : 32 f'm. - Italie : 50 lires - Espagne : 3 pes. 5

Le journal d'un seul jour

THEATRE DU VIDE

LE théâtre se cherche depuis toujours ; il se cherche depuis le début perdu.

Le grand théâtre, c'est l'Eden en fait ; l'important est d'établir une bonne fois nos positions statiques, chacun d'une manière individuelle et non plus personnelle dans l'univers. Depuis longtemps déjà j'annonce partout que je ne connais pas d'autre aujourd'hui ! Je tiens à dire aussi : « Je suis l'acteur, je suis le compositeur, l'architecte, le sculpteur. » Je tiens à dire : « Je suis. » L'on m'objectera sans doute que cela a déjà été hurlé de toutes sortes de manières variées ; c'est certainement juste. Par conséquent, je répète peut-être cela, mais conscient, bien conscient d'avoir atteint le droit de le dire : et voilà que, pour moi comme pour tous, il n'y a plus rien à faire ; le théâtre officiel, aujourd'hui, c'est « être » et je « suis » effectivement tout ce que l'on veut bien que je « sois » et même tout ce que l'on ne veut pas que je « sois » ! J'atteindrai même à ne plus « être », du tout un jour !... Mais, que l'on ne s'y trompe pas : il ne s'agit pas de moi quand je dis je, moi, mon, etc.

C'est parce que l'esprit dans lequel je vis est un esprit d'émerveillement, stabilisé et continu, un esprit nouveau classique, que je n'ai aucun caractère d'avant-garde qui, elle, vieillit si vite, de génération en génération.

Mon art n'appartiendra pas à l'époque, pas plus que l'art de tous les grands classiques n'a appartenu aux époques où ils ont vécu, parce que je cherche avant tout, comme eux, à créer dans mes réalisations cette « transparence », ce « vide » incommensurable dans lequel vit l'esprit permanent et absolu délivré de toutes dimensions !

Non, je ne me laisse pas prendre à mon propre jeu en parlant aujourd'hui d'un théâtre du vide avec un tel avant-propos orgueilleux, égocentrique et même vaniteux sans doute en apparence : mon théâtre prendra une valeur universelle dans la mesure même où mes compagnons réaliseront mieux ma pensée que moi-même je ne la connais, car s'ils sont des milliers, ils la réfléteront des milliers de fois alors que moi je suis seul.

Je me rends très bien compte que je me présente, tout seul, en écrivant ces lignes avec ce qui semblerait une sorte de complexe du plus fort. Je signale à ceux qui seraient assez aveugles et maladroits pour me donner l'avantage d'attaquer mon exaspération du moi qu'il est bien facile de m'entraîner à la défaite mais à cette sorte de défaite que sont les veilles des grandes victoires définitives pour ceux qui entrent dans le grand jeu et savent s'exposer.

J'ai lutté contre ma vocation de « peintre », en partant au Japon pour y vivre l'aventure Judo et Arts martiaux anciens : de même j'ai lutté contre ma vocation « d'homme de théâtre » ; mais précisément, le Judo par la pratique physique et spirituelle des Katas, s'est constitué malgré moi, ma formation dans cette discipline de l'art qu'est le théâtre, d'une manière imprévisible, mais tout aussi profitable et profonde, sinon peut-être plus encore, qu'importe quelle autre. De ce qui suit, j'obéis à une nécessité profonde, j'agis en réaliste idéal de gros bon sens. J'aime Molière et Shakespeare parce que, dans cette recherche du vide qui me fascine, je me trouve cette transparence du tout synonyme de « Représentation » ou de « Spectacle ».

Pour moi « théâtre » n'est pas

L'ESPACE, LUI-MÊME.

ACTUALITÉ

DANS le cadre des représentations théâtrales du Festival d'Art d'Avant-Garde de novembre-décembre 1960, j'ai décidé de présenter une ultime forme de théâtre collectif qu'est un dimanche pour tout le monde.

Je n'ai pas voulu me limiter à une matinée ou à une soirée.

En présentant le dimanche 27 novembre 1960, de 0 heure à 24 heures, je présente donc une journée de fête, un véritable spectacle du vide, au point culminant de mes théories. Cependant, n'importe quel autre jour de la semaine aurait pu être aussi utilisé.

Je souhaite qu'en ce jour la joie et le merveilleux règnent, que personne n'ait le trac et que tous, acteurs-spectateurs, conscients comme inconscients aussi de cette gigantesque manifestation, passent une bonne journée.

Que chacun aille dedans comme dehors, circule, bouge, remue ou reste tranquille.

Tout ce que je publie aujourd'hui dans ce journal est antérieur à la présentation de ce jour historique pour le théâtre.

Le théâtre doit être ou doit tout au moins tenter de devenir rapidement le plaisir d'être, de vivre, de passer de merveilleux moments, et de comprendre chaque jour mieux le bel aujourd'hui.

Tout ce que je publie dans ce journal ont été mes étapes jusqu'à ce jour glorieux de réalisme et de vérité : le théâtre des opérations de cette conception du théâtre que je propose n'est pas seulement la ville, Paris, mais aussi la campagne, le désert, la montagne, le ciel même, et tout l'univers même. Pourquoi pas ?

Je sais que tout va fonctionner très bien inévitablement pour tous, spectateurs, acteurs, machinistes, directeurs et autres.

Je tiens à remercier ici M. Jacques Polieri, directeur du Festival d'Art d'Avant-Garde, pour son enthousiasme et en me proposant de présenter cette manifestation « le dimanche 27 novembre ».

Yves KLEIN.

Stanislavsky, réaliste extrémiste, aurait souhaité la mort effective et définitive de l'acteur qui doit jouer en scène. Le précurseur Dada Vakhtangof enferma le public dans une salle de théâtre pendant deux heures dans le seul but cynique de les enfermer tout simplement. Cet événement faisait partie, d'ailleurs.

D'importants chercheurs qui, eux, ont été d'avant-garde, comme Taïroff, par exemple, voulaient théâtraliser le théâtre.

Evreinoff rêvait du monodrame, de la théâtralisation dans la vie quotidienne, pensée - geste - parole.

Ce que je désire : Plus de rythme, surtout plus jamais de rythme !

Et puis mon œuvre n'est pas une « recherche », elle est mon sillage. Elle est la matière même de la vitesse statique vertigineuse, à laquelle je me propulse pour place dans l'immatériel ! Attention encore, je tiens à bien préciser que je ne dis pas, en parlant de mon œuvre : « C'est bien plus beau parce que c'est inutile » ! Non, je dis : « C'est ainsi que cela sera ainsi, et personne ne pourra jamais rien faire pour que ce ne soit pas ainsi » ! Pourquoi ? Parce que, précisément c'est « classique » !

...Ainsi, très vite, on en arrive au théâtre sans acteur, sans décor, sans scène, sans spectateur... plus rien que le créateur seul qui n'est vu par personne, excepté la présence de personne et le théâtre-aspectacle commence !

L'auteur vit sa création : il

● SUITE EN PAGE 2

leurs, de son « théâtre de la révolte » et s'intitulait « La Soirée insolite ».

Le Tchécoslovaque Burian créa un théâtre synthétique ; les personnages de sa pièce, « Roméo et Juliette », étaient des machines fantastiques et infernales qui évoluaient sur la scène pendant que les acteurs en coulisse disaient le texte. Amphithéâtroff montait des piécettes laconiques de dix minutes, coupées de discussions ; les discussions faisaient partie évidemment du programme. Ce qui l'amèna à déclarer souvent à son public, qui lui commandait d'avance ses représentations, qu'il était prêt à supporter les tomates, les œufs pourris, mais, en aucune manière, les pavés.

Les phonographes, dans « Les Mariés de la Tour Eiffel », de Jean Cocteau, sont aussi très beaux phénomènes.

★

Il serait trop long de citer ici toutes les tentatives qui ont été faites pour sortir de la convention, de l'optique apprise, de l'académisme, dans le domaine du spectacle de la représentation théâtrale depuis le début du siècle. Je crois que presque tout a été fait, jusqu'à Jacques Polieri dans sa mise en scène de la pièce de Tardieu ces temps derniers, qui fait entendre des voix sur la scène où trois panneaux-écrans sont là pour tout décor et toute présence ! (Son idée d'ailleurs est de faire vivre et parler les décors.)

Bravo ! — Quel bonheur que tout cela ait existé, mais attention ; j'avertis bien le lecteur, mon œuvre théâtrale n'a rien, absolument rien à voir avec l'une quelconque de ces directions ou recherches sauf peut-être, avec celles d'Antonin Artaud, qui sentait venir ce que je propose aujourd'hui ici. Cependant Artaud, comme bien d'autres « Grands » du vrai théâtre, se perdait dans cette fausse conception artificielle et intellectuelle du Verbe qui en a dérouté tant si longtemps. Pour moi, par le ne sais qu'une chose, c'est « qu'au commencement était le Verbe, et le Verbe était Dieu » ; deux fois « être » pour deux fois « Verbe » plus « Dieu », en tout cinq points qui, si on les médite un peu, disent bien ce qu'ils veulent dire : le « Verbe » dans cette aforme n'est pas « Parole » articulée ni même désarticulée.

(Photo Shunk-Kender)

Le peintre de l'espace se jette dans le vide !

Le monochrome qui est aussi champion de judo, ceinture noire 4e dan, s'entraîne régulièrement à la lévitation dynamique ! (avec ou sans filet, au risque de sa vie).

Il prétend être en mesure d'aller rejoindre bientôt dans l'espace son œuvre préférée : une sculpture aérostatique composée de Mille et un Ballons bleus, qui, en 1957, s'enfuit de son exposition dans le ciel de Saint-Germain-des-Prés pour ne plus revenir !

Libérer la sculpture du socle a été longtemps sa préoccupation. « Aujourd'hui le peintre de l'espace doit aller effectivement dans l'espace pour peindre, mais il doit y aller sans trucs, ni supercheries, ni non plus en avion, ni en parachute ou en fusée : il doit y aller par lui-même, avec une force individuelle autonome, en un mot, il doit être capable de léviter. »

Yves

« Je suis le peintre de l'espace. Je ne suis pas un peintre abstrait, mais au contraire un figuratif, et un réaliste. Soyons honnêtes, pour peindre l'espace, je me dois de me rendre sur place, dans cet espace même »

Sensibilité pure

Une petite salle.

Les spectateurs, après avoir dûment payé chacun leur entrée, assez chère, pénètrent dans la salle et prennent place.

Le rideau est baissé. La salle illuminée.

Dès que la salle est pleine, un homme se présente sur la scène, devant le rideau toujours baissé et déclare :

« Mesdames, Messieurs en raison des circonstances, ce soir nous allons être contraints de vous enchaîner chacun à vos sièges (et, de plus, vous bâillonner) pour la durée de la représentation.

» Cette mesure de sécurité est nécessaire, afin de vous protéger contre vous-même, en présence de ce spectacle particulièrement dangereux, d'un point de vue affectif pur »

» Nous exprimons d'avance nos regrets aux personnes qui ne pourraient supporter d'être ainsi enchaînées et bâillonnées avant le lever du rideau et nous les prions aimablement de bien

vouloir quitter la salle pour se faire rembourser à la sortie. Aucune personne non enchaînée solidement n'étant du reste tolérée dans la salle pendant le spectacle. Merci »

» ...Aussitôt un groupe d'enchaîneurs-bâillonneurs pénétrent dans la salle et, systématiquement, rang après rang, paralysent rapidement tous les spectateurs.

● SUITE EN PAGE 2

Krefeld. January 14-February 26, 1961.
"Monochrom und Feuer," Museum Haus Lange, Krefeld.
Fire Column and Fire Wall in the garden of the Museum.

38

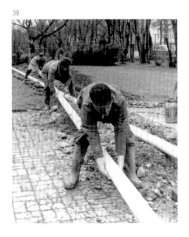

39

40

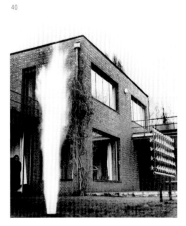

Plan for the Krefeld exhibition.
Blue and red ballpoint pen on paper,
22.5"x29.5"

>

Fire Column and Fire Wall
in the garden of the Museum.

>>

41

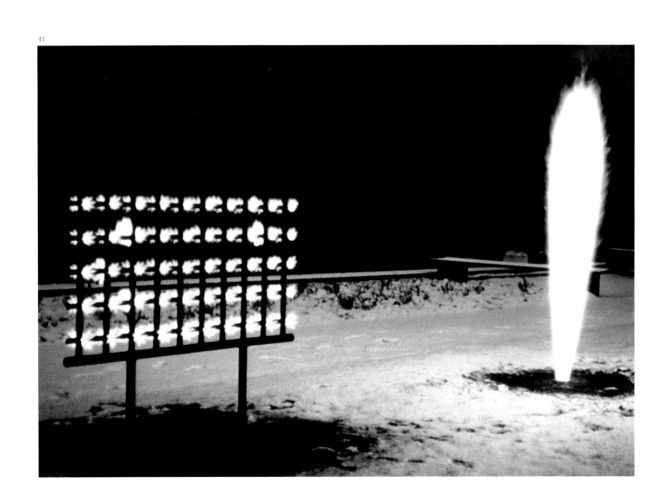

éventuellement
les trois grandes
« Flammes »
peuvent être
placées près
du mur du
Feu — juste
devant la
Fenêtre du
Musée —

Pelouse

PARC

Pelouse

ENTRÉE

trois Grandes Flammes f...

3 m. de Haut
80 cm de diametre
de corps de Flamme

au gaz
ou à l'Huile
lourde

Pelouse
Sol

4 m

1m
0,75

mur de Feu Ville
au gaz

Musée de KREFELD
arch.te Mies van der Rohe

exposition Y. Klein

dispositif de fontaines
de Feu et mur
de Feu
dans les Jardins

Janvier 1960

42

43

44
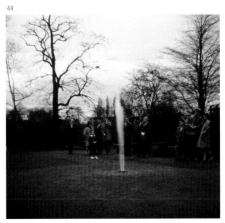

45

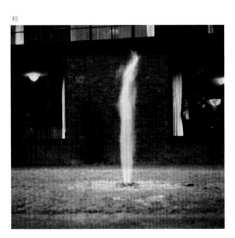

46

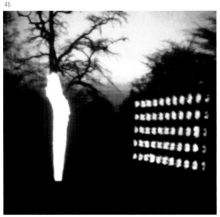

47

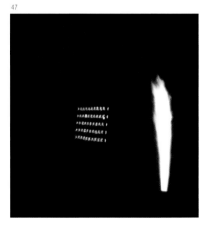

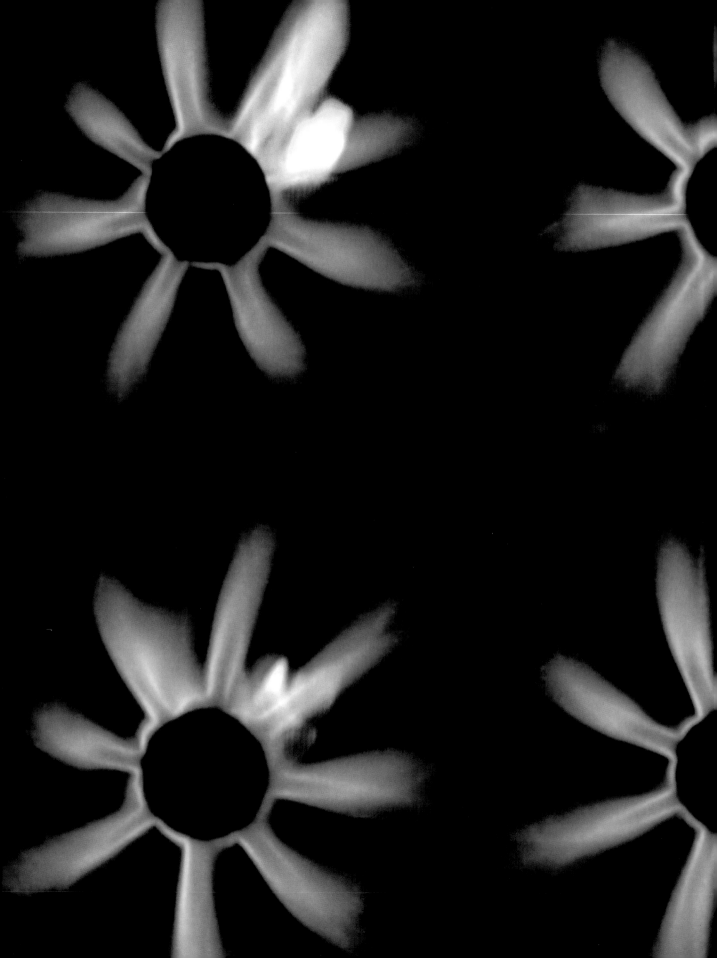

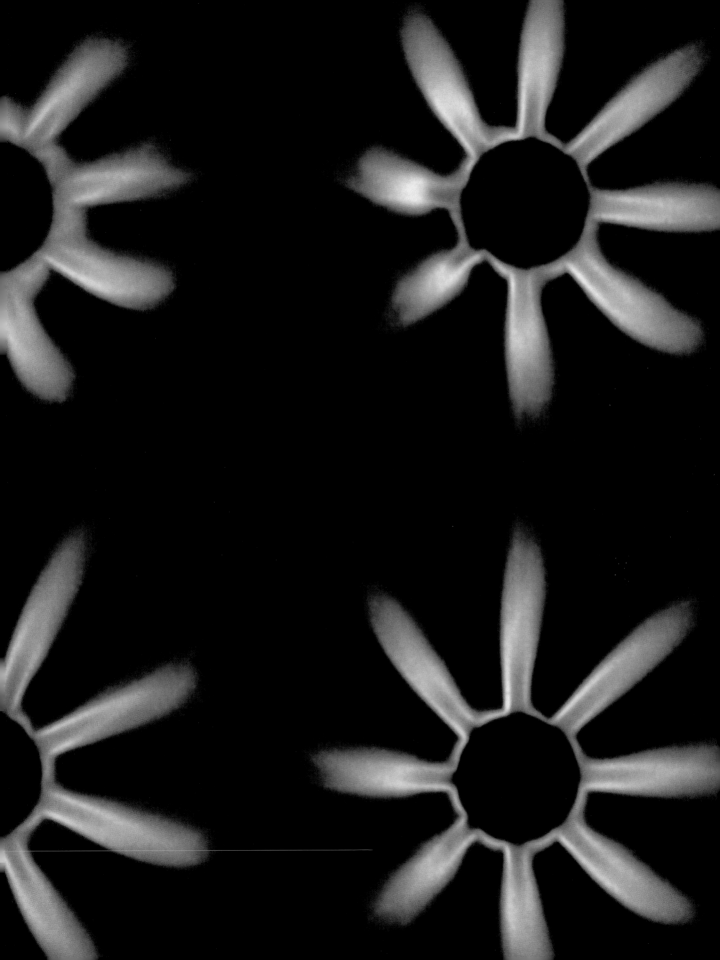

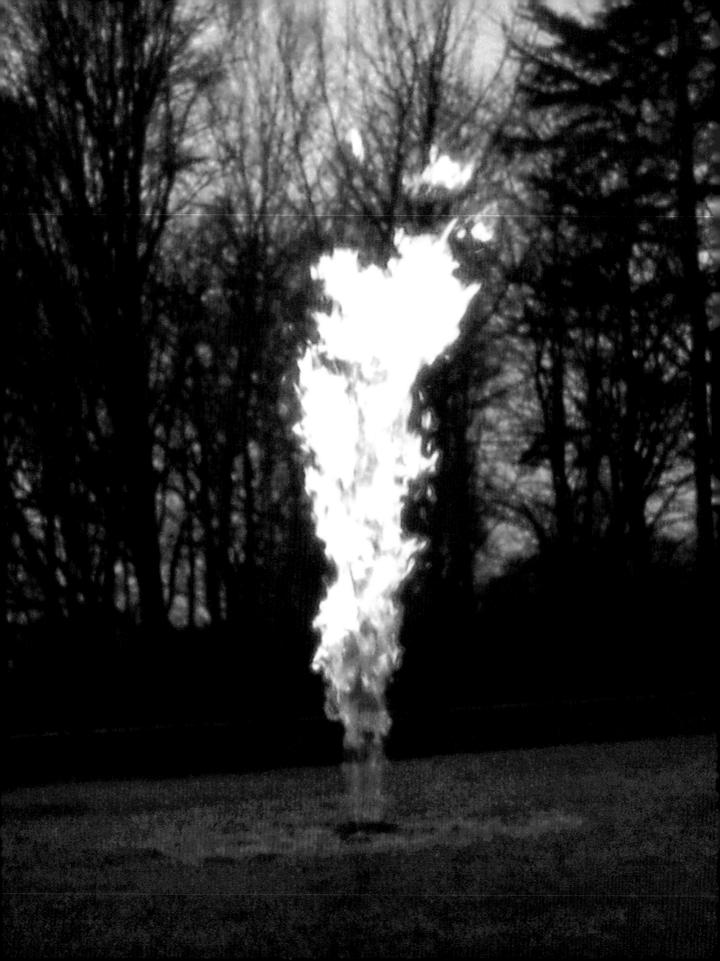

Krefeld. January 1961.
Yves Klein in the Void Room, Museum
Haus Lange,
photographs by Charles Wilp

50

51

Raum der Leere.
"Void Room," 1961,
Collection Museum Haus Lange,
Krefeld, Germany

52

New-York. April 11-29, 1961.
Yves Klein in New York harbour.

Malibu. May 1961.
Yves Klein fishing.

53

54

Malibu, May 1961.
Yves Klein creating a Sponge Relief.

55

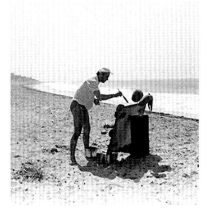

France. July 18-19, 1961.
Fire Paintings and Anthropometries at Gaz de France,
Saint-Denis, France

56

57

58

59

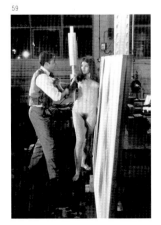

60

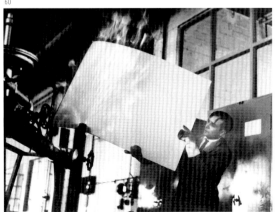

61

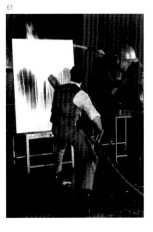

Cité climatisée - Accès à l'éden technique.
"Air-Conditioned City - Access to Technical's Eden"
10"x14" Ink and Pencil on Paper,
Collaboration Yves Klein - Claude Parent - Sargologo,
Private Collection

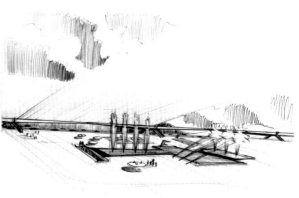

Project of an Air Architecture.
Yves Klein - Werner Ruhnau.

Air Architecture has in our mind always been just a transitory stage, but today we present it as means for air-conditioning privileged geographical spaces. The illustration shows a proposal for protecting a city by means of a roof of flowing air. A central expressway leading to the airport divides the city into a residential section and a section for work, industry, and mechanical equipment.

> The air roof regulates the temperature and at the same time protects the privileged area
> There is a ground surface of transparent glass
> There is an underground service area (kitchens, bathrooms, storage, and utility)
> The concept of secrecy, still common in our world, has disappeared in this city, which is flooded with light
> and completely open to the outside
> A new atmosphere of human intimacy prevails
> The inhabitants live naked
> The former patriarchal structure of the family no longer exists
> The community is perfect, free, individualistic, impersonal
> The main activity of the inhabitants: leisure

Obstacles formerly accepted in architecture as annoying necessities have become luxuries:

> Fireproof walls
> Waterproof walls
> Airborne forms
> Fire fountains
> Water fountains
> Swimming pools
> Air mattresses, air seats

The true goal of immaterial architecture: air conditioning of vast geographic residential spaces.

Rather than being accomplished by technological miracles, this temperature control will become reality through a change of human sensitivity into a function of the cosmos.

The theory of *"immaterialization"* negates the spirit of science fiction.

The newly developed sensitivity, a new human dimension, guided by the mind, in the future will transfigure climatic and spiritual conditions on the surface of our earth.

To want means to envision. Attached to this wish is a determination to experience what one envisions, and the miracle occurs in all realms of nature.

> *Ben Gourion: "He who does not believe in miracles is not a realist."*

Zero Magazine, Düsseldorf, July 1961.

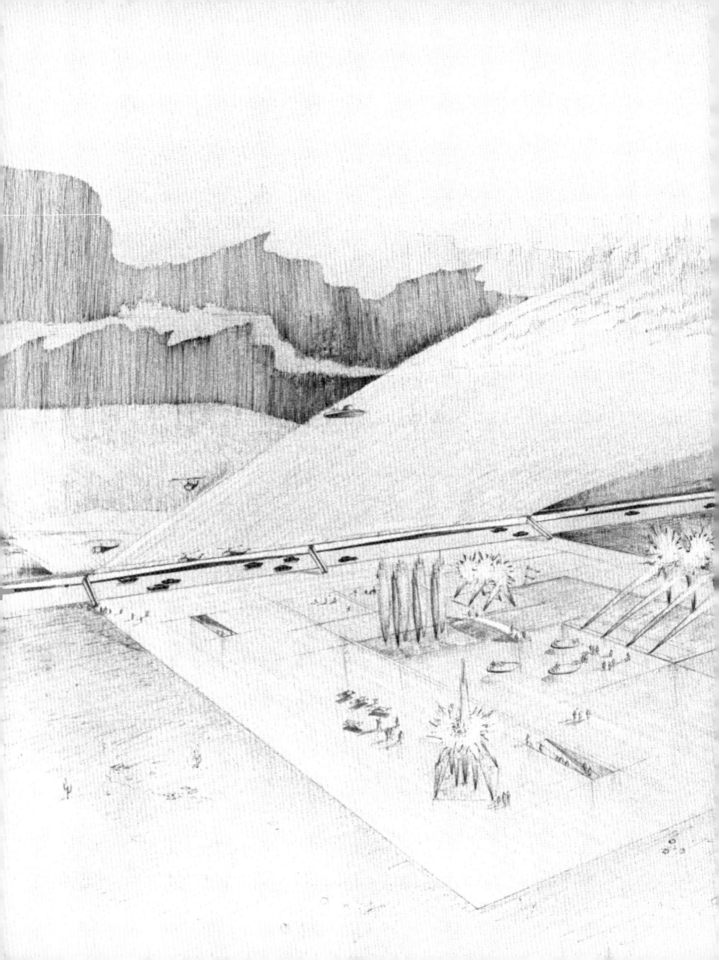

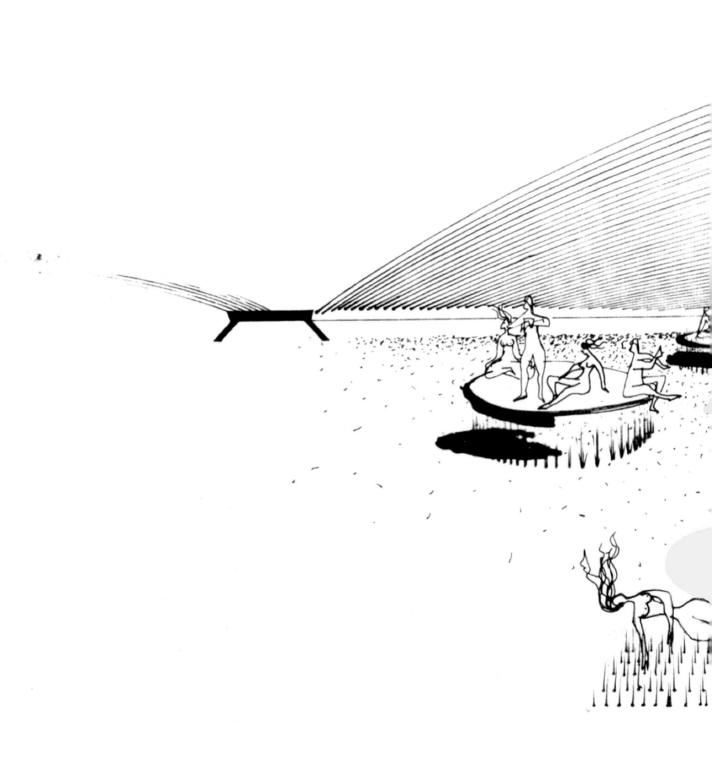

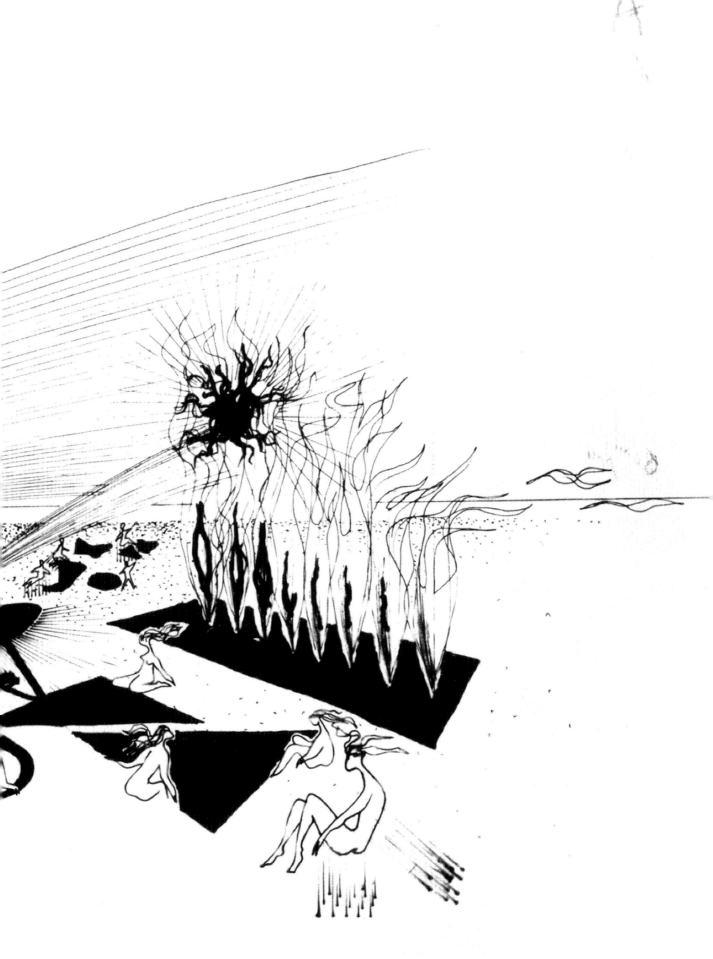

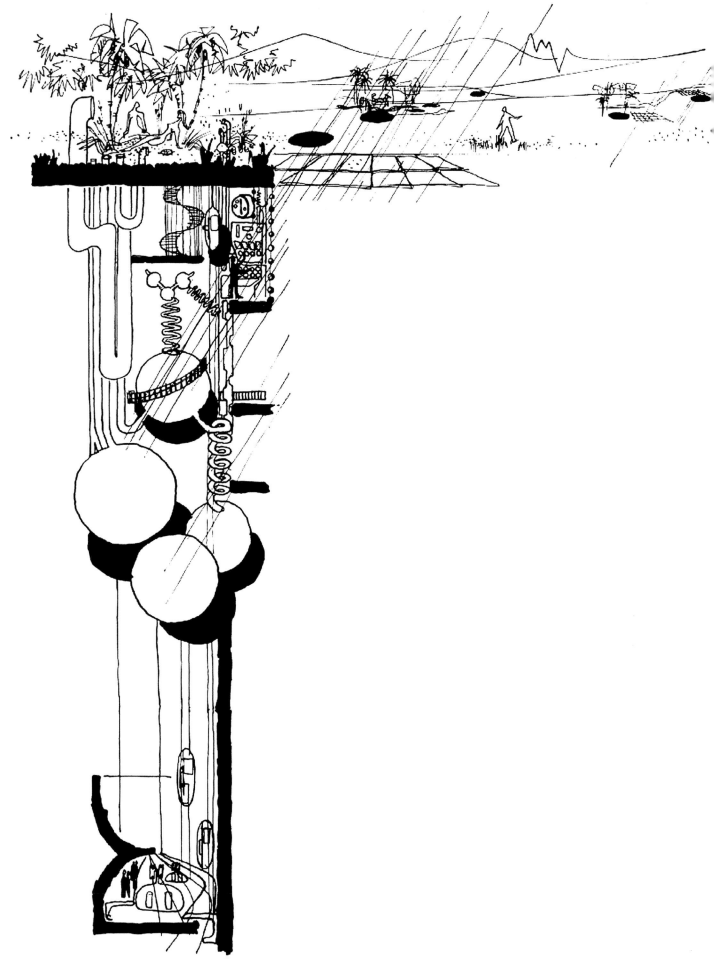

Cité climatisée (toit d'air et murs de feu)
"Air-Conditioned City (AirRoof and Fire walls),"
1961, 20"x 27" Ink and Pencil on Velum,
Collaboration Yves Klein - Claude Parent,
Private Collection

Sous-sol d'une cité climatisée.
"Underground of an Air-Conditioned City,"
1961, 29"x 19" Ink and Pencil on Velum,
Collaboration Yves Klein - Claude Parent,
Private Collection

" La climatisation de l'atmosphère à la surface de notre Globe "

... la conclusion technique et scientifique de notre civilisation

est enfouie dans les

entrailles de la terre et assure

le confort par le contrôle absolu du

climat à la surface de tous

les continents, devenus vastes

salles de séjour communes.

.... C'est une sorte de retour à l'éden

de la légende. (1951.)

. Avènement d'une société nouvelle, destinée à

subir des métamorphoses profondes dans sa

condition même. Disparition de l'intimité

personnelle et familiale. Développement

d'une ontologie impersonnelle.

la volonté de l'Homme peut enfin

régler la vie au niveau d'un

" merveilleux constant "

L'Homme libre

l'est à tel point, qu'

peut même léviter

Occupation : Les loisirs

.. Les obstacles autrefois subis dans

l'architecture traditionnelle

éliminés.

Soins du corps par des méthodes

Air conditioning on the surface of our globe.

...The technical and scientific conclusion of our civilization is buried in the depths

of the earth and ensures

the absolute control of the Climate

on the surface of all the continents

which have become vast

communal living rooms.

.....It is a sort of return to the garden of Eden

of the legend (1951).

..The advent of a new society destined

to undergo deep transformations

in its very condition itself. Intimacy, both personal

and in the family, will disappear. An impersonal

ontology will be developed.

The willpower of Man will at last regulate life

on a constantly "wonderful" level.

Man is so free

he can

even levitate!

His occupation: leisure.

The obstacles that

traditional architecture used to put up with

will be eliminated.

"Architecture de l'air," (ANT 102).
"Architecture of the Air,"
1961, Dry Blue Pigment in Synthetic
Resin and Charcoal on Paper on Fabric,
103"x84"
Collection Tokyo Metropolitan Museum,
Tokyo, Japan

Body care will occur through new methods,

such as "The air bed."

Projet pour les Fontaines de Varsovie.
Project for Warsaw's Fountains,
1961, 26"x35" Ink on Velum on Canvas,
Collaboration Yves Klein - Claude Parent,
Private Collection

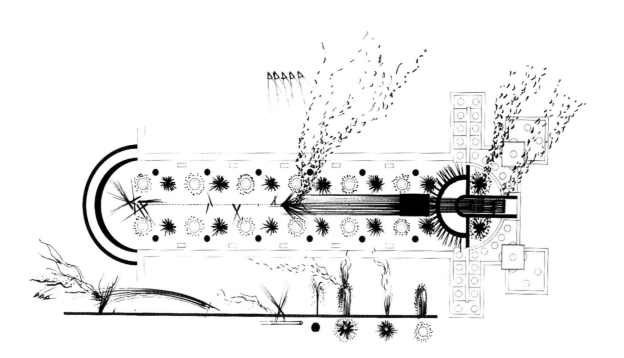

Les Fontaines de Varsovie.
Warsaw's Fountains,
1961, 33"x43" Ink and Pencil on Paper,
Collaboration Yves Klein - Claude Parent,
Private Collection

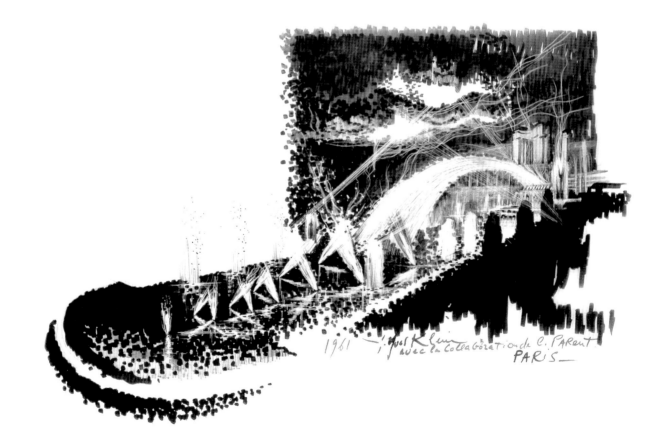

"Europe-Afrique," (RP 11).
"Europe-Africa,"
1961, Planetary Relief, Dry Blue pigment
in Synthetic Resin on Gesso on Board,
31"x 19"
Private Collection

Paris. November 1961.
Making of Planetary Reliefs spraying IKB resin on 3D
Maps from The National Geographic Institute

62

63

Paris. March 17, 1961.
Yves Klein working with Claude Parent's drawings.
14, rue Campagne-Première, Paris.

64

During a Conversation. Yves Klein.

During a conversation on architecture with Professor Boucharts, I suddenly asked him the following question: What is architecture? With some difficulty he answered, *"It is space, limited by protective partitions to protect the private life in which we live."*

I retorted that, in my opinion, one could not add anything to space. Architecture is space and that is all.

What is space? Space is what is immaterial and especially unlimited and this is precisely what fully and unfailingly explains and justifies the development of architecture towards the immaterial for the past fifty years!

We shall return to nature but of course in a future beyond our human lives in this century.

Another conversation brought more light to the great crusade of the return to the Garden of Eden through Air Architecture.

Werner was coming back from a lecture he had given in Baden-Baden on the evolution of architecture and more particularly on the development of the architecture of theaters throughout the evolution of civilization. This conversation can be summed up as follows: Werner said, *"I have spoken of the conditions in which theaters have been built in each period, in the very spirit of each of these periods…. So I came quite naturally to Air Architecture and, as I do for other periods, I asked myself a question, which I will immediately answer: With such an immaterial architecture, what type of theater will correspond to it? And there, in front of the audience, I had a feeling of panic without finding any answer because the only answer was that no theater could be included in this concept of architecture."* I said theater would then be the tangible, material, emotional, and spiritual every day life and each person would become both actor and spectator. The theater would no longer exist as an artificial world set apart, it would be everywhere at the same time since we would have reached the end of the cycle of involution-evolution throughout the world of transient psychology into which we have been thrust by Adam and Eve's deed.

During this conversation, Werner pointed out that we would ask Balenciaga to create some fashion designs for the inhabitants of such an architecture of the future. We all thought of something like tights. A young girl who had joined us in our conversation took it into her head to suggest, on the contrary, that everyone in this civilization of the immaterial would be naked without shame. At such a level of finalization, when things have been made so clear, why bother about clothes?

Until now I answered by avoiding the question as cleverly as I could, by maintaining that intimacy would still exist all the same, that it would be preserved, etc. But now I answer not at all; indeed, intimacy will disappear completely and with it everything that kills and destroys us every day. That is to say, again, this psychological world we have mentioned so often, which forces us to have some intimacy because it does not give us a good conscience, which proves that the fact of requiring intimacy is not good, not beautiful, it means that we have something to hide.

We will no longer be able to hide anything in this type of Air Architecture. It is indeed an important step, which has been taken on the path leading back to the Garden of Eden where we will live once again with one another without being ashamed. We will each, separately, play our psychological part on the stage of this world, in the face of the universe and of our real life, our life for life, using everything that used to make use of us: feelings, emotions, passions and finally the whole range of all our complexes.

We will thus be in the Garden of Eden as in the beginning with Adam and Eve, and this time we will have to be careful not to eat the fruit of knowledge but instead the fruit of life.

Paris, January 26, 1962.
Receipt stub of the Dino Buzzati Zone of
Immaterial Pictorial Sensibility.

Pont-au-Double, Paris. February 4, 1962.
Sale of a Zone of Immaterial Pictorial Sensibility
to Claude Pascal.

64

65

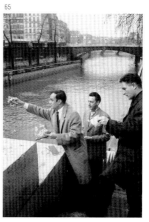

SÉRIE N° 1　**N°**　05

UNE ZONE DE SENSIBILITÉ
PICTURALE IMMATÉRIELLE

Vingt Grammes
d'Or Fin

Mon~~ Dino~~

Buzzatti

Paris le 26 · 1 · 19 62

SÉRIE N° 1

CACHET DE GARANTIE

N°　07

Reçu Vingt Grammes d'Or Fin
contre une Zone de Sensibilité Picturale Immatérielle

CETTE ZONE TRANSFÉRABLE NE PEUT ÊTRE CÉDÉE PAR
SON PROPRIÉTAIRE QU'AU DOUBLE DE SA VALEUR
D'ACHAT INITIALE.
(SIGNATURES ET DATES POUR TRANSFERTS AU DOS).
LE TRANSGRESSEUR S'EXPOSE À L'ANNIHILATION TOTALE
DE SA PROPRE SENSIBILITÉ.

le　*19*

Yves Klein

Paris. January 26, 1962.
Yves Klein removing paintings to make a Void with François Dufrêne and Jacques
Villeglé, Musée d'Art Moderne de la Ville de Paris, Photographs by Harry Shunk.

66

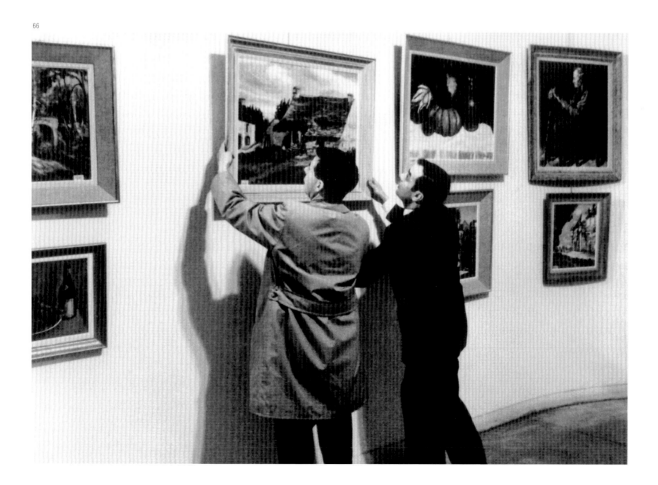

67

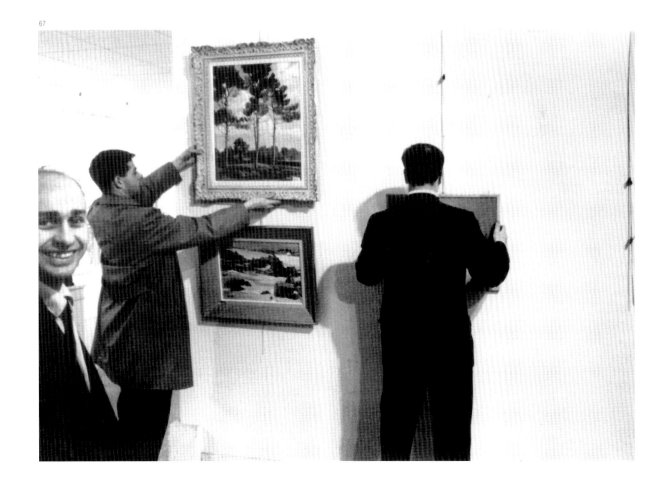

Paris. February 1962.
Yves Klein, 14, rue Campagne-Première, Paris

68

Air Architecture and Air Conditioning of Space. Yves Klein.

For the past ten years I have been dreaming, as much a waking dream as possible, of a sort of return to Eden!

Eden: This biblical myth is no longer a myth for me. I have always wanted to think of it in a positive, constructive, cold, and realistic way. To my mind, there has never been any question of it being an exotic dream!

I have ceaselessly constructed this spiritualized image of this Garden of Eden in an infinite number of probably unknown dimensions. My life has constantly been integrated in this Eden, I moved about in it and existed in it just as truly as I move about in the physical and tangible world.

Sometimes I wanted to try and materialize it, so I thought of technique! The world of science fiction was smiling at me in its stupid, foolish way with solutions such as solar mirrors, for example, or also heating rivers in winter, creating artificial gulf streams that cross seas and oceans, changing the direction of great winds from hot countries, directing them towards cold countries and vice versa.… Of course, with all the progress made by science, this is no longer a utopia today. Technique, however, could in fact realize such things!

However, the fact of thinking of technique with the intention of carrying out anything as soon as an idea comes to mind, has always made me feel ill at ease in an indefinable way. To my mind, technique is not worthy of the great and true achievements of Man.

True creation is magical and spontaneous. From the beginning it must never be indebted to money, calculations, mathematics, and technique!

Creation must suddenly exist one day for its creator and the next day for all the others without exception, but also without dispute.

Yet I am not against technique; no, this is how I conceived this idea of Air Architecture as a possible new stage on the path towards the immaterialization of architecture, which will in fact be Eden returned, geographic nature air conditioned.

To my mind, we are arriving in a new era in the human realm regarding nature and the universe but not in the way some people think, the romantic and fanciful spirit of the nineteenth century; that is to say, in an all powerful technical era. It is quite the contrary: We are entering a new magical atmosphere, using the new human forces such as totally pure and indisputable sensibility, imagination, and will power!

Such attempts have been made by all sorts of inventors but they were guided by no spiritual or vital need. They were just proposing nothing more than mere novelties.

I can remember very clearly when this idea came to my mind, probably around 1950. Everyone laughed at me and my apparently romantic thoughts! In 1958 I managed to persuade Werner Ruhnau to materialize this idea of Air Architecture. From then on the Ruhnau-Klein collaboration came into being, and the valiant architect, like myself, suffered the usual jokes in his turn. In Germany they called him the architect of *"castles in the air,"* an expression that in French translates to *"building castles in Spain!"*

Ruhnau very bravely gave many lectures to defend this idea of air architecture bringing many improvements, which made it more acceptable to the general public, especially through intelligent technical demonstrations.

But the problem still remained the same for me. What I wanted was, in fact, Eden!

To find nature and live once again on the surface of the whole of the earth without needing a roof or a wall. To live in nature with a great and permanent comfort.

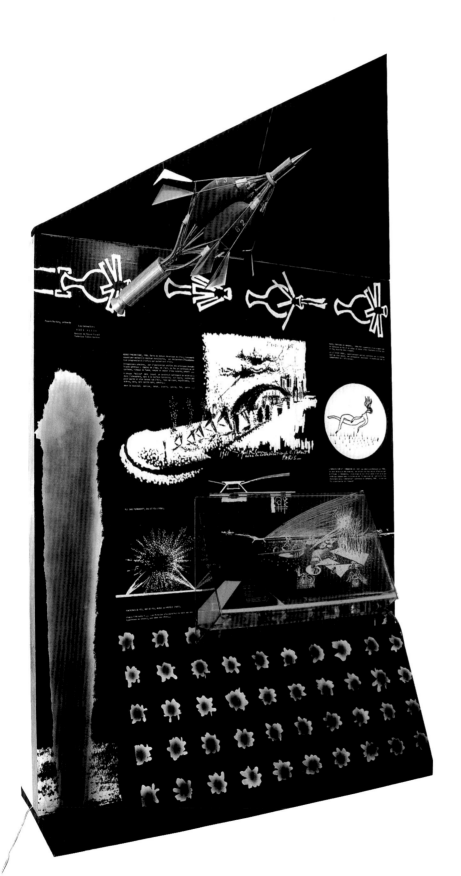

Paris. March 7, 1962. L'Architecture de l'Air.
"Air Architecture,"
Billboard, Group Show: "Antagonisme 2 : l'objet" at the Musée des Arts
Décoratifs, Collaboration Yves Klein - Claude Parent - Roger Tallon,
Private Collection

Rocket pneumatique (maquette Tallon-Technes).
"Pneumatic rocket,"
1962, 32" x 25" x 30" Painted metal and rubber,
Private Collection

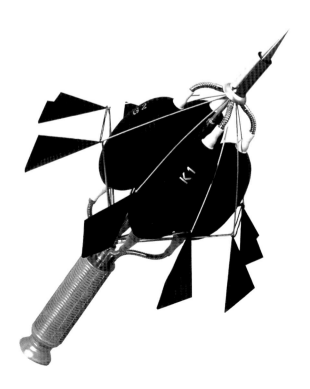

" O FOUDRES...," (F 126).
"O THUNDER....,"
1962, 5"x5" Burnt Cardboard,
Private Collection

>

O lightening planets and rockets

By fire and by water

Yves Klein crusader

Opposite and against all

By a single jet purifies

The space of the painting

By fire and by water

In the great flaming blaze

Of the constellated void

Yves Klein reconstructs

The virgin iris of the eye

By fire and by water

Yves Klein crusader

Passes through the blue of the flame

Original cleanser

History of the painting

O lightening suns and dew.

Poem by Andre Verdet, May 1962.

40 Years Later.

Claude Parent. A Letter.

Claude Parent is an architect and writer. He created the "Function of the Oblique" with Paul Virilio from 1963 to 1969. He produced most of the drawings of Air Architecture.

I had been familiar with so-called avant-garde artistic circles since 1950, so I inevitably knew about Klein's artistic activity: the Void exhibition, etc. However, I really got to know him when he came to my office, when he asked me to help him to express his ideas and theories - Air Architecture, the combination of air and fire, the golden age - through first-rate drawings that would do him credit.

He explained to me in detail his theories, his ideas about the future of humanity. It was up to me to manage, to illustrate this world in a visually coherent representation (a very dreamlike world, even if Klein was perfectly capable of giving it life and reality). This was the challenge.

My role was to feel, understand, and merge into his ideas, and then make them burst forth and take shape (in an architectural or other form) accessible to educated people who, regarding the majority of them, I must admit, were totally unresponsive to his ideas and unfortunately remained so, at least as far as the French are concerned. The precondition was that I should accept his way of thinking and then ensure communication, thanks to my work. This was easy for me (in spite of my very rational turn of mind), due to the strength of his convictions and his charm, something which was usual with Klein. This communicating strategy seemed necessary and obvious when you saw the continual hesitations of such a cultivated and sensitive person like Gérald Gassiot Tallabot, and when you looked at the ridiculous drawings that Klein's friends would concoct for him in order to try and ineptly express his ideas. It was disastrous.

I must say that never in the least did Klein have a true relationship with architecture. It is true that he worked a lot and had discussions with [Werner] Ruhnau, the architect, when he installed his sponge sculptures and monochromes in Gelsenkirchen. Therefore, from the beginning there was this essential relationship, but for reasons that are unknown to me, Klein parted with Ruhnau and thus became orphaned regarding architecture. He came to me because in the fifties I was the architect who most readily listened to artists and gave shape to their maddest architectural fantasies (Nicolas Schoeffer, Jacques Polieri, Yaacov Agam, Jean Tinguely, and André Bloc). Well, these are the minor aspects of the story. In any case, this partnership lasted several years and I brought in [others] (especially concerning Polieri for some time, solely for Klein) and one of my associates at the time, Mr. Sargologo, who was very sensitive.

I must say that Klein had no favorite building and no favorite architect either. For Klein, architecture was rather a detail, an anecdote. What counted for him was the art of living, communicating with nature becoming once more, in a very esoteric way, one of the components of nature with the fundamental elements regarded as being the only possible constituents, air, fire, water, etc. And it did not consist in a very definite type of architecture.

He had no interest in walls or fences except when they were immaterial and in a romantic German context. This explains the presence of voluntarily excessive smoke volutes (on his request) in the Varsovie fountains at the Trocadero in Paris. When I suggested trails in the Paris sky he was mad with joy.

The other definition, which was much more important, was the air roof; that is to say, an immaterial enclosure protecting an open space where humanity would live freely, naked - a new life, a golden age. Air, void, an unlimited horizon, weightlessness; all this allowed [people] to be free and live without constraint, without any limits, without any sort of fence, without any obstacle. Weightlessness leads to virtual reality in architecture and a total fusion with nature.

It seems to me that Yves Klein's ancestors were druids, partly Nibelungen and partly Rheingold, and especially the symbolic enclosure during the crusades, the golden age of *amour courtois* (courtly love). Of course, he refers to King Arthur.

In the world today I do not find anything like this apart from the theory called *"The Function of the Oblique,"* worked out by Paul Virilio and myself in 1964. Namely:

1. refuse any visible enclosure;

2. the horizon is regarded as continuous and predominant;

3. continuity, meaning that there is an unknown beginning and an uncertain end.

It is true that there is a future for these theories but we will miss the magic of Yves Klein and his power to persuade people who are under the influence of materialism. We can only believe and hope. There is something fabulous about his unfinished destiny, despite ones sadness about it.

To François Perrin, Paris, April 22, 2002.

Roger Tallon. Interview.

Roger Tallon is the designer of the French High Speed Train (TGV). He helped Yves Klein throughout his career on technical issues.

François Perrin: What part did you play in the Air Architecture?

Roger Tallon: On the one hand, I am a scientific engineer; on the other, I am open to all forms of delirium. I did not overestimate him nor did I underestimate him. What I liked about Klein was that he was in a system, a trip; everything was logical in his approach to Air Architecture. I also helped him in his research concerning fire. I put him into contact with the French gas company: *Gaz de France*. I was already using fire, but the way I was using it was dangerous. I used kerosene.

FP: What was the reason for this?

RT: I did paintings like [Jackson] Pollock but I set fire to them. I had calculated that, as [my studio] was a cellar and there was no oxygen and therefore the fire would die out. If there had been any oxygen it would have blown up everything in the district. [Klein] had seen this and was impressed by it. It was spectacular. As for Air Architecture, I had never thought about it. I started taking an interest in it because he was working with [Werner] Ruhnau, who had not given him much help. The other day I found some documents. I searched for those ventilation ducts all over the world. The real problem about Air Architecture is noise. I have worked on the TGV: The wind causes problems and that is what creates noise. The more space we would have covered the more noise we would have had. He had found a solution by producing *more* noise. However, all this was make-believe because up until now this idea of dealing with noise by making more noise has not been experimented. That would be a good idea in noisy districts, but no solution was found for this problem. I started to take an interest in this and I discovered the *Coranda Effect*. A company had bought the trademark and gave a demonstration with a lawnmower engine. It had a nozzle like the mouthpiece of a clarinet and if you directed it towards a chair, it would jump into the air. It was like an air laser. I had never seen this system apart from water jets in fountains. Therefore, I worked with people from the waterworks to see what could be done. Without the Coranda system there is no effect. After that, I worked on the nose of the TGV. That was why Klein was such an interesting person.

FP: What about the pneumatic rocket?

RT: That was funny. [Claude] Parent did a drawing and I did a similar drawing. Klein said to me, *"You see it moves forward. The air goes in, it inflates this thing so the arms fold up, and this chases the air away."* He had not realized that in space there is no air. But it was interesting and we enjoyed doing it.

FP: Did you build a model of the air roof?

RT: Yes, I did, for the Air Architecture exhibition at the Musée des Arts Décoratifs in 1962, *"Antagonismes."* My system was concealed and nobody could see it: It was covered by a mound and part of a motorway with grass on either side. There were a few cars and people in the fields and underneath. You could see structures below ground level in accordance with his theory. I wanted to create an autonomous system but I could not manage to get the right pressure so I had to install a pump from the Air Liquide Company, with whom I was working just then. I [used] a big carboy of compressed air and inside it was a whole system of compressors that projected water on the sides. People could push a button and the water would begin to come down; you could see drops of water on the tiny people and then, all of a sudden, the air fan would start up. The water would drip along the sides and the people were no longer wet. With the Coranda system, I wanted to create a crisscross effect in same way as optical fibers but here it was air spouts that could sweep over the surface of, for example, a room like this one, even if it made some noise.

FP: Could it have been done in a larger size?

RT: Yes, it could, but there was the noise. I think he was not conscious of the noise. In the air there was something else; he was very disappointed that he could not finalize this. I remember one day in a medical journal I read that an Englishman had invented an airbed for victims of third degree burns, and it had been patented. Yves became hysterical when he saw that. It consisted of some *"micro"* substance, which supported the injured without there being any contact. It was patented; I showed it to Yves to encourage him. I was hard with him because I wanted him to go as far as possible. In many cases he obtained results. In this case he was experimenting.

FP: It was visionary…

RT: He had a *"mono"* way of dealing with things. He did not try to find a solution to a problem; he tried to carry out what he had in mind. He applied for patents. As far as I am concerned, all the inflated things we made settled that problem. That is the meaning of air. Why should one want to use air in its rough form whereas you can use it in so many ways such as airbeds? I also worked with Germans in Osaka in 1970.

FP: In Osaka there was this building made of artificial fog. The idea was used again at the 2002 Expo in Switzerland for the Blur Building .

RT: I went there last summer with a friend. The fog looked fine. It did not always work. Some meteorological conditions gave hopeless effects. Sometimes it went too fast and you were drenched. They gave you a Bin Laden type of raincoat to protect you from getting wet, which was not very pleasant. You could walk around inside, which was fun. It was finer on the outside than inside. Inside you were in the fog. Many countries have this kind of fog. Fairgrounds also have machinery that allows you to float. My problem concerning these projects is not only technological. Technology is only a means; I am thinking of the result. The wind is not a very good thing for human beings, from a medical point of view. We all know that convertibles can cause bad colds. I know that when I went to Japan without having any

preconceived ideas, not thinking of Yves, I found everything over there: the Monogolds, the Buddhist temples, the imprint of religion. Finding these marks means finding that person's soul. I also found the martial arts. I recently saw a film by Bruce Lee and it reminded me of Klein. He regarded judo as something very important. The master in the Bruce Lee film said that martial arts depended on one's character and energy. That was Yves, because generally we used to go to bed at two o'clock in the morning and he got up at seven o'clock, whereas I got up at ten. He only slept for five hours each night and it finally had an effect on his health. It is true that his death came as a sort of implosion. My wife, who is a doctor, told me that his heart had burst. I thought of the life he led, his superego. He [felt] there was no obstacle of time or distance, so he never took it easy. When I was with him, I realized that we did not have a rational relationship. I do not mind if someone does something that I cannot fathom, that is why we got on well. He communicated with two types of people: those who were completely astounded and those who were positive. A crazy Vietnamese designer named Quasar was the sort of person who could have got on well with him. His theory was that our society is becoming lighter in every way, the opposite of weighty both physically and morally. He had a strange automobile; it was a transparent cube. He sold a few of them but they were dangerous. When I was with Klein, we never spoke of architecture because he was no longer interested in it. He no longer wanted to have anything to do with it. He wanted the earth to become a natural landscape. He wanted to destroy everything that related to production and energy. Today he would have supported the Green Party. I am convinced of that.

FP: What do you remember the most from him?

RT: It was a real pleasure to be with Yves. He was serene, he was not very tall but he conveyed a sense of tranquility. I think this came from Asia; it was in his genes. You must not forget that his grandmother was Indonesian. Most of the artists that I know are obsessive monomaniacs, but Klein was not so. When he died, Rotraut did not come to the funeral because she was pregnant. The weather was wonderful that day, and she looked at the blue sky from the window of her flat and said, *"That is Yves."*

Paris, April 30, 2003.

Werner Ruhnau. Interview.

Werner Ruhnau is the architect of the Gelsenkirchen Opera, where he commissioned Yves Klein for his work. Together they started the first drawings, experiments, and texts on the Air Architecture.

François Perrin: When did you meet Yves Klein ?

Werner Ruhnau: I met Yves Klein in Paris at the end of March 1957. He gave to my wife Anita and me the first monochrome that was going to come in Germany. I was looking for artists to collaborate on the Gelsenkirchen Opera with Norbert Kricke. I met him at Gallery Iris Clert, where he was presenting his work. He was with his girlfriend, the architect Bernadette Allain, and she knew instantly what I was looking for. The concepts of Mies Van der Rohe, inside and outside. She helped him put together some proposals for the lobby. He designed giant blue monochromes, and his project was selected.

FP: How did you started talking about Air Architecture?

WR: In his work, colors were a climate of the space. What he was seeking was a paradise. He wanted to have a good climate, so we proposed to build environments that would provide this good climate.

I think it was Yves who came with this idea of the roof of air, to have a protection and air conditioning the space. I understood it instantly and said, *"Let's do some experiments!"* That was in 1958. We did many days of air and fire tests at the factory of Küppersbusch. We used the same machine on which we made the experiments for the air conditioning of the theater. We designed a project for an *"air café"* in front of the Opera. The main idea was to protect people from the rain outside with a curtain of air. We showed to the client the roof of air, but we had an energy problem. We did a model of the café and the client said no. I never found a client after that. The clients are too stupid....

Everything started in our workshop in Gelsenkirchen. We finished the theater in 1959 and I lost a lot of money on the project. The town was really unfriendly to us.

FP: You participated in the lecture at the Sorbonne?

WR: Yves Klein asked me to join him for a lecture to present the principles of Air Architecture. He asked me to write a text for this occasion, and I did a presentation on the evolution of the theater. Iris Clert was at the same time presenting an exhibition of the drawings and models of our work in Gelsenkirchen. She went to the German embassy to organize the lecture. They rented the room and paid for the invitation.

FP: What is your vision of this project now?

WR: In our climate, it doesn't work. They made some experiments in Toronto, but Air Architecture doesn't work with this technique. We were influenced by the work of Buckminster Fuller and Mies Van der Rohe and wanted to push farther their directions. It was also very related to the book *Architecture without Architects*, where the basic function of architecture is to protect against the bad weather.

FP: What do you think of the projects Yves Klein produced after working with you?

WR: The drawings of Claude Parent were more of a fantasy, but why not?

FP: What do you remember the most about him?

WR: He was a wonderful comrade, cracking one joke after the other. Whenever we met he was saying, *"Long live the European situation! Air conditioning the space!"*

Ketwig, May 1, 2003.

Pierre Restany. Interview.

Pierre Restany is an art critic. He founded the New Realists and was Yves Klein's biographer.

François Perrin: For you, what was the Air Architecture?

Pierre Restany: All the same, the fact is that [Werner] Ruhnau experienced this utopia. He experienced it from within. [Claude] Parent illustrated the concepts of Klein's utopia, so to speak. He accepted it, even showed enthusiasm, but did not initiate it. The same goes for Tallon. That is why I told you about a sort of co-ownership as to the origin of this idea. He had vaguely conceived of the need for a school of sensibility but maybe it was for populist reasons and strategies in communication. You must not forget that scandal prevailed all during Klein's career. He rejected his close surroundings-that is to say, the *"artistic scene"*- apart from a few exceptions, which are important, in fact, but he went on living in disagreement with these ideas as if the fact of listing them one after the other would cause a sort of mental rash for his readers. He always kept to that idea. However, it did not prevent him from having a special relationship with Parent and artists such as [Lucio] Fontana and [Piero] Manzoni. He was intensely aware of there being a deep structural hostility against his ideas, and in some of his writings one feels that he fought against that. Therefore, the more he was involved in the continuance of his work and his destiny, the fate of his destiny, the more, at regular periods, he wanted to explode, which in his case corresponded to a new moment of this continuity, which progressively came into being and which he endeavored to explain. You cannot imagine how many times I listened to him, how many times he asked me to give him some advice particularly concerning the meaning of some of the words he used, for example, in his Chelsea Hotel Manifesto. I remember that he sent me a cable from New York to ask me if he had to justify himself; I told him that it was not necessary. This type of utopian way of thinking receives great attention in this part of Europe. If you classify a logic of revision as utopian, that is enough for it to be devalued.

FP: How do you look at this part of his work?

PR: An important aspect is the fact that this utopia is part of an activity that is characteristic of Yves Klein. He was always endeavoring to save the world by going back to nature in his technical Eden. Another interesting point is that he was both a mutant and a believer, and therefore his mind appeared under both disguises in this festive atmosphere made up of great joys and great serenity that were part of a sort of a rediscovered happiness. I do not think that Yves Klein thought that those who were going to use Air Architecture would consider the relation with space in terms of comfort. It was seen, rather, from a mystical or idyllic standpoint.

He certainly did finally create a type of architecture, but only by relinquishing the most constant and unvarying values of architecture, such as intimacy. He believed that the person who would inhabit his city had to be free and happy, and many things had to take place daily in a state of grace. One enters Klein's air-conditioned space by conditioning oneself from an emotional point of view and becoming one of the elements of this city of joy. I really think this is extremely important.

FP: When did he talk about it for the first time?

PR: The first time must have been around 1958 when he permanently ceased his search for color in his different colored monochromes and became immersed in blue. I felt that all the metaphors that were used to justify the choice of blue, the exclusive IKB blue in his own vision had something to do with this idea of happiness. Finally, of course, blue is the color of the void, it is the color of life, and it is the color of deep emotion. But at the same time, for Yves Klein, it was above all the color of happiness. Blue makes you happy. In 1948, he was looking at the sky in Nice. He had a very architectural vision of color, especially because color in itself conveys energy, cosmic energy that is fundamental. This seems to me the most urgent notion: It is precisely this idea concerning monochromes, and then the idea of space associated with a happy feeling, the space belonging to the person who uses it, the blue revolution. Air Architecture is a space devoted to happiness.

FP: When did he start using the expression "Air Architecture?"

PR: It was during his first collaboration with Ruhnau at the end of 1958. I was present at the Sorbonne Conference. Being someone who was so familiar with the man and his work I went through a feeling of painful tension. He was similar to what he had appeared to be several times previously: very artificial. Only towards the end of his speech did he freely give way to his outbursts of intuition. He managed to develop a very direct dialogue style in Italy where an exhibition of his work was held in Milan in January 1957. On this occasion, he met Fontana and it was the beginning of a very deep friendship. Fontana had returned from Argentina about ten years earlier. He had made his White Manifesto and Fontana's operational concept was the idea that painting fixes space. For Fontana, painting monochromes was a way of introducing the hint of a third dimension inside the second dimension, a sort of spatial aura, an aura that diffuses the energy that was put into place by the colors. Yves Klein supported Fontana's intuition that painting was both color and space fixed in the fullness of its brightness and its deep sensibility. That is why when Fontana met Yves Klein, there were only monochrome backgrounds [in his work] during the period when he put holes and slits. This discussion concerning monochromes allowed him to find an argument to justify the attack against the integrity of the canvas. This return to monochromes allowed

Fontana to answer an objection concerning his fundamental legitimacy: He did not consider that the fact of going from a dot to a hole, and from a line to a slit, proved a deliberate intention of attacking the integrity of the canvas. The aim was merely to find this integrity on another level, that of a spatially active element, which was at the core of his intuition and was extremely important. Yves Klein was very conscious of that. This had given him great pleasure; he was very fond of Fontana.

It also played a very important part in the development of Manzoni's work. We had met Manzoni in Milan at the time and both knew him well. Here is an anecdote about him. He really was somebody, the son of an aristocratic family from Lombardy, but, like all the sons of well-off families inspired by artistic ambitions, he was dressed like a tramp. Yves Klein's exhibition lasted ten days and during those ten days, someone looking like a tramp would come at six o'clock and stay until eight o'clock in the evening. The owner of the gallery was suspicious because he thought he was a tramp who was waiting for a moment of inattentiveness to steal what could be stolen. One day we discovered that the tramp happened to be Manzoni. He asked us to follow him and led us to his studio in an apartment in Milan. At the time, he was using a sort of informal style to which he added numbers. This was not very convincing and we went back to Paris with a rather negative impression regarding him. In fact, from 1957 onwards - that is to say, the end of that very year - Manzoni gave up his informal style in order to start an adventure that turned out to bear a resemblance to Yves Klein's destiny. He painted monochromes; he replaced whitish compositions by white ones that tended to create a sense of balance. He called them *"achromes,"* that is to say, colorless. Suddenly you realized that this person was going to establish his destiny in association with Yves Klein, although with a slight handicap; he came rather late, and this delay began to accumulate. Each great quotation corresponds to a moment of his destiny. He had come back to the idea of omnipresent energy fully circulating in space and this energy was for him the active element of his personal sensibility. Each of us had a share of this cosmic universal energy and this is what brought about all the combinations of language and expressiveness. Where Manzoni was wrong was that he applied Klein's pattern of distribution and utilization of energy in a very Catholic way so that finally this cosmic sensitivity was a suicide of the soul. It could appease the body with life and it came at the instant of death. Manzoni became a sort of inspired person who adopted a behavior associated with a great determination. I was the witness of Yves Klein's very strong and attractive power.

FP: What was his opinion on contemporary architecture?

PR: He had very few points of reference concerning architecture since you know well that his knowledge in that field was very incomplete. I think I sometimes heard him mention Le Corbusier.

On the one hand he was quite fascinated. He was amazed by the *"modulor,"* the idea that space could adapt to man's dimensions. He considered that as a very important problem, a wide-ranging problem as was the case for judo. On the other hand, he thought that Le Corbusier's vision was too limited. The idea of allocating a system of quotas to the proportions of the body and creating a calculated controllable system of ergonomics annoyed him. Regarding Le Corbusier's rigorousness, he admired and often spoke about the Chapelle de Ronchamps. You must not forget that he died in 1962. With Ruhnau the problem arose very early on, followed by the idea of really considering air as building material. Therefore, he had made some experiments with compressed air [during which] he realized that you could air condition small spaces, keep out the rain, and create a roof. Of course, he could not avoid noise problems caused by compressed air on much larger surfaces. It soon became quite intolerable. Here is how the system worked: There was a blowing engine and another engine that captured the air, and between these two the compressed air created a sort of surface, a stable column. He had been interested in the discussions that took place in England between English physicists and neurologists who had constructed a real airbed, which was probably the first example of compressed air design. It allowed one to lie on it in a horizontal position. We both went to see the chief executive of Air Liquide in Paris, thanks to François Mathey, who was the director of the Musée des Arts Décoratifs in Paris (Museum of Ornamental Art). The CEO of Air Liquide thought we were mad and suffering from mental masturbation. He pressed a security switch and two colossal men led us out of his office. All this gives an idea the difficulties that he was going to face. He was a cross between a Christian and a mutant. He was convinced that what he wanted very much finally happened. When [Yuri] Gagarin made his first steps in outer space and said that the earth was blue when seen from out there, it confirmed Klein's vision. He was convinced that contemporary technology would solve all the problems and that a technical solution would be found concerning compressed air, partly eliminating the noise. For Yves Klein it was a global concept. He could not be restricted to the concept of void or transparence. The problem had to be considered globally the way Yves Klein had communicated it to Fontana. Color had to be thought of as a phenomenon of precise and coherent tension. From that point of view, anything like architecture connected with void or transparency is mere simulacrum. Simulacrum is worth thinking about, but I think that all the same we were on that level.

FP: Did you hear of the Blur Building?

PR: Yes, I have heard about it. It is more like a performance, something very interesting. No doubt that it is more than simulacrum since it refers to the absence of structure that becomes a supporting structure. It is a play on words concerning the fluidity of space, but I still think it is very much of a performance.

Paris, May 7, 2003.

Essays.

Buckminster Fuller. 1962.
Dome over Manhattan

69

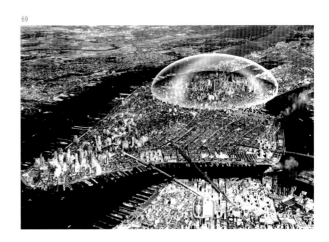

The Architecture of the Leap. Mark Wigley.

November 27, 1960. Paris newsstands are infiltrated by counterfeit copies of the newspaper *Dimanche, le journal d'un seul jour*, the Sunday edition of *France-Soir*. In the middle of the usual dense display of political scandals, sports events, and movie stars, a headline now screams *"A Man in Space!"* and a documentary photograph shows someone in a dark suit leaping away from the top of a building. Leaping out and up. Almost flying. Captured in the fragment of a second before gravity will surely pull his soft body onto the hard street below. A body about to be broken. A sense of a disaster just about to happen pulls the eye away from all the usual daily reports on events that have already occurred. Yet the jumper poised in space seems to have no sense of impending crisis. Strangely ecstatic, his body arches itself towards the sky, eyes eagerly lifted up rather than down, arms outstretched to embrace what is coming rather than defend against it.

Who would do such a self-destructive thing so earnestly? The caption below explains that *"The Painter of Space Leaps into the Void."* It is an artist then, the kind of person who is expected to radically challenge traditional assumptions, and might even be extremist enough to willingly abandon the security of solid structures for the insecurity of the air. Furthermore, this man in space is apparently a painter of space. He is leaping into that which he usually paints, leaping beyond the familiar material world. While most of the photo is dark, filled in by the density of buildings, streets and trees, the top right corner is white, and it is towards the emptiness of this seemingly immaterial white void that the artist is fatally drawn.

Yet the artist is actually leaping toward architecture rather than away from it. One of his pointed shoes still lightly touches the building. Suspended forever in the instant before take-off, the body acts as a bridge between the building and the void. Architecture finds itself tied to what seems to be beyond it. The painter uses his body to introduce architecture to its outer limits. Architecture is forced to see itself differently. The meaning of the

material building changes. Despite its stubborn assertion of a clear static form, its seemingly hard outer edge, its very substance becomes infused with the immaterial void.

Not by chance had the leaping painter Yves Klein spent the previous two years collaborating with the architect Werner Ruhnau on a project that turns the most insubstantial elements of architecture into its most substantial force. That the project has long been forgotten is understandable since the whole idea was for an architecture that disappeared, an architecture on the limit of visibility. Space was now to be defined by ephemeral means. The only role of material is to act as a springboard to the immaterial. The more insubstantial a material, the bigger the role it plays in generating a new kind of architecture. The Air Architecture manifesto that concludes Klein's lecture of June 3, 1959 at the Sorbonne on *"The Evolution of Art Towards the Immaterial,"* begins by insisting that all ephemeral materials, starting with the blue sky, become construction materials:

> First of all, blue light as a building material, corresponds to void; Energy must be used in the stratosphere; in the the atmosphere heavy air or any other gas that is heavier or more dense than air will be used as a building material air or along with heavy air, optical fire effects, magnetism, light and sound.... Air, gas, fire, sound, odors, magnetic forces, electricity, electronics are materials.

When the project takes its final form, the solid ground of the city is turned into a vast sheet of transparent glass, exposing all the services below to the inhabitants who are endlessly exposed to each other as they move nakedly across the glass surface, protected from the elements by a vast *"air roof"* formed by a controlled stream of air above them. The only trace of this roof is in its effects, the absence of rain, wind, or extremes of temperature, or color added to the air that forms it. Under the sweeping curve of the invisible roof, a new kind of open space, a *"vast communal living room,"* is defined in opposition to the physical

and psychological constraints of the solid city. In the most radical extension of the realized modernist dream of free spaces of movement contained only by sheer walls of glass, Klein and Ruhnau dream of inhabitants moving around in the gap between glass floor and air, occupying a depth of the most ephemeral materials, like living inside the very depth of a window, happily exposed to the world, neither inside nor outside. A space without shame or solid limits, an idyllic garden in which even a glass house or tower would seem too heavy, a Garden of Eden as Klein kept insisting, a paradisaical state of purity achieved with the most primeval elements: air, fire, and water.

Tall fountains shoot up from the middle of swimming pools and are met by angled jets of fire producing a steaming vaporous frenzy, while people rest on blasts of air or elliptical discs hovering over the glass. Architecture is undone by the primeval matter, which comes before it. Fire and water being, for Klein, *"a non-architecture which I want to integrate to this constantly evolving architecture."* Solid architecture is infiltrated and ultimately dissolved by what seems to be outside it.

This project clearly resonates with a number of experimental visions generated between the late fifties and the early seventies. Ruhnau was a member of the Groupe de L'Architecture Mobile (GEAM), orchestrated by Yona Friedman in 1958, who were committed to the fluidity and mobility of urban life and called for an architecture of the city that was as free as its occupants. In the hands of designers like Yona Friedman, Constant, Frei Otto, and Eckhard Schultze-Fielitz, architecture became lighter and less predictable. Solid unmoving masses gave way to perforated and ever-evolving networks. The early twentieth century architect's mission to dematerialize the wall, the limit between inside and outside, is radicalized to produce interiors so vast that they act like exteriors. A new kind of pastoral space emerges, in which minimalist architectural forms are treated as evolving organic entities rather than fixed enclosures. Architecture becomes as mobile as the lives it shelters. Air Architecture took this kind of thinking to an extreme, clearly picking up key aspects of Constant's New Babylon project, for example, with its society of endless leisure, its burial of all the machines below ground, and dissolution of the family.

Yet Klein and Ruhnau's vision polemically rejects the use of high technology materials and geometrically sophisticated geometries that characterize the megastructural projects of their colleagues. The usual, vast spider's web of steel space-frame acting as a scaffolding to sustain new kinds of space and lifestyle does not appear. Metal itself is gone, along with all the other materials that have been in anyway reworked. There are no alloys, reinforced concrete, laminates, plastics, fibers-not even a simple woven fabric. The raw materials of the architecture are precisely that: raw. The sheet of glass that takes over from the ground, allowing everyone to fly even when walking, is the most solid and most reworked material encountered. Yet even glass is a material found in the earth, simply melted and poured into a new shape, as is the fire, water, and air used above. To be more precise, it is not just all the technical machinery of the new society that is placed underground. All the new materials, all the solids that have been reworked into new useful materials, from the first alloys to the latest polymers and electronic circuitry, are placed underground. Klein will eventually prepare sections through the project that show the high technology machinery and plumbing running deep below the surface. Only the underground part of the project looks similar to the above ground technological extremism of the other experimental architects. The solid material world is buried so that people can live in the immaterial:

I would like to speak rapidly about a great architectural project which has always been close to my heart; the realization of a dwelling which is really immaterial but emotionally, technically and functionally practical. In air one builds with air (immaterial - material). In the ground one builds with soil (material - material).

This *"immaterial"* architecture resonates with the thinking of Buckminster Fuller, the guiding light behind most of the radical projects of the megastructural architects. Fuller's conviction was that architecture is, in the end, invisible, that reducing physical form down to its absolute minimum allows the hidden shape of the universe to emerge, that architecture in its purest form is a form of radiation.

Klein likewise had his eye trained on the invisible, and engaged with architecture precisely in order to embrace the invisible. He accepted Ruhnau's suggestion in May of 1957 that they collaborate on the decoration of the Gelsenkirchen music theatre in order to expand the role of the monochromes that had so impressed Ruhnau two months earlier. The already famous blue surfaces were no longer to be exhibited within a ready-made space but grew so big and assumed such a unique texture and three-dimensional depth that they became the major elements defining the space and thereby turning the building into just the scaffolding for an entirely different architecture. This shift in status led Klein to reflect on both the spatial effect of painting and the pictorial affect of architecture, eventually fusing the two together in the concept of Air Architecture. His 1958 text, *The Monochrome Adventure*, a new kind of text that tries to retrospectively monitor the evolution of his work, suggests that in any collaboration between a painter and architect on the decoration of a new construction, the architect should only concentrate on the strictly utilitarian aspect of the building while the painter provides *"the dizzingly poetic-pictorial climate all throughout the new atmosphere of the construction."* The primary role of the added layer of color and texture is atmospheric, the intangible effect that begins precisely where the physical surface of the building or painting stops, the effect that cannot even be seen directly in the color that is added. The key to the new architecture is atmosphere itself, that which cannot be seen or touched. The role of the painter is simply to add *"a sensible life, a warmth, that the building itself will have acquired in collaboration with its inhabitants but over a much longer time."* Color both inhabits and transforms space. In the end, the aim is a certain confusion of the color and the life of the inhabitants. A new architecture emerges out of this confusion:

Color is impregnated in space, it inhabits space…color is free! It is instantaneously dissolved into space…. For me, the colors are living beings, highly evolved individuals who integrate themselves to us and to everything. Colors are the true inhabitants of space.

The retrospective narrative of the Sorbonne lecture of the following year explores this shift from paintings in space to the space emanating from paintings in more detail. Again the central force mobilized by the artist is atmosphere. The hyper-visible monochrome creates the *"invisible but present…climate and the pictorial ambience"* in a given space, and the visitor *"should be literally impregnated by the pictorial atmosphere."* The limits of the person and room are simultaneously dissolved by the atmosphere. The surface of the painting is colored in such a way that the surface itself no longer exists as a hard limit. It becomes porous, like Klein's sponges, with the color going through it into the viewer and the viewer going through it into the color. The point is *"becoming immersed in space"* rather than passing through it like a tourist. Like the colored surface, the inhabitant can no longer be distinguished from the space being inhabited. Life itself becomes the *"raw material"* of the space. The ultimate ambition of the artist is therefore an *"immaterial architecture,"* an endlessly porous architecture, one that does not need to be dissolved any further. It is unlike the seemingly transparent buildings of Mies van der Rohe, a vast pictorial atmosphere to be occupied: *"I was to come to air architecture because only there could I at last produce and stabilize pictorial sensibility in a raw material state."* Klein insists that the monochromes had already launched this concept of Air Architecture even if he did not at first understand them in architectural terms.

For Klein, traditional solid architecture is an *"anti-space"* whose effects have to be actively countered to liberate space. The built environment is a constricting prison he describes himself as trying to escape for ten years by focusing on the void. Yet the only way to move to the void is to leap into it. The move from anti-space to space is necessarily a leap:

> We will thus become men of the air, we will feel the force of attraction driving us upwards, towards space, towards nowhere and everywhere at the same time. Having thus controlled the force of attraction we will literally levitate in a total and spiritual state of freedom.

The photograph of the *Leap into the Void* made in October of 1960 and published the following month is therefore an integral part of the Air Architecture project. At the time, Klein was working on the final plans for his first presentation of the Air Architecture concept as part of his first retrospective exhibition at the Kaiser Wilhelm Museum of Krefeld. Not by chance, the first *Leap into the Void* at Colette Allendy's gallery on January 12 came barely three weeks before Klein was invited to have the exhibition. The retrospective impulse, the leap, and new architecture are somehow linked together. Each sudden leap into the unknowable future seems to follow a careful retracing of all previous artistic steps, and architectural invention seems to act as the springboard. The momentum grows as the pattern is repeated. The 1958 retrospective text leads up to the idea of collaboration on decorating existing buildings; the 1959 retrospective text culminates in a manifesto for Air Architecture; and the 1961 retrospective exhibition seems to build up towards the first built manifestation of the new architecture.

Klein relished the chance to put his work in dialogue with the architecture of Mies van de Rohe's Haus Lange that bad been placed at the disposal of the museum. He proposed a *"small presentation of the architecture of the air,"* and asked Ruhnau to complete the drawings for the exhibition. But when Ruhnau didn't do them, Klein prepared his own rough drawings for the

"urban integrations" of water and fire that were rendered more precisely by Claude Parent, who had helped him to visualize Air Architecture since the middle of 1959. Mies's small domestic project was to be used as a vehicle for commentary on urbanism. In the end, it didn't happen. Yet the only trace of the Air Architecture project turned out to be the most infamous. A gas company was asked to run pipes over to the house (again the technology is buried so that only its effects are experienced), and a huge jet of flame shoots three meters into the air from the snow-covered ground in front of the house alongside a porous wall made of fire. This kind of fire architecture started with experiments that Klein did with the sculptor Nobert Kricke on fountains of fire for the music theatre project in late 1957 and evolved with further experiments with Ruhnau into walls of fire that were then continued with Parent. In July of 1961 it was presented in typical architectural descriptions and drawings in an issue of Zero, but it was not until March of 1962, that Air Architecture is literally presented as such at the Musée des Arts Décoratifs with two panels and a scale model of the air roof, complete with naked figures moving happily below the stream of air that cuts off the simulated rain. The architecture of the invisible atmosphere finally becomes visible.

Yet the key to the project was already to be found elsewhere in the 1961 exhibition, the so called Void room that Klein presented in the only closed off space in the house, one that had been added after the war. The only space that does not participate in Mies's polemical transparency, the one that needed to be dissolved the most, is transformed by Klein into his most extreme statement of the ultimate dissolution that will render even Mies's glass architecture too solid. Klein simply painted it white. A white room would be exhibited as such in the exhibition rather than acting as an exhibition space. In making this radical gesture, Klein repeated his infamous installation of a Void room in April 28, 1958 at the Iris Clert gallery in Paris. Forty-eight hours before the opening, he entered the room and painted every surface white. The point was to exhibit the very condition of painting itself, its invisible atmospheric force, an intangible effect that people

had to pay to see, or, rather, not see, and could even purchase. With this empty room, painting became architecture, as reported in the Sorbonne lecture:

> To create an ambiance, a pictorial climate which is invisible…this invisible pictorial state of the space in the gallery should in every respect be what has so far been offered as the best definition of painting in general, that is invisible and intangible radiance…one is to be literally impregnated by the pictorial atmosphere…thus I think that the pictorial space that I have previously been able to stabilize in front of and around my monochrome paintings will henceforth be well established in the space of the gallery.

Not by chance does painting become architecture in the very beginning of Klein's collaboration with an architect. Architecture is used to escape itself and present painting in its purest form, the white being more an erasure of traditional architecture, the dissolving of an anti-space. Air Architecture is primarily produced by erasing everything superfluous from architecture where superfluous no longer means just decoration, as it did to the modern architect, but structure as well. Solidity gives way to atmosphere: *"What I want to present here tonight is not the walls of this gallery, but the ambience of this gallery. I painted the walls of this gallery only in order to see clearly in my own atmosphere."* This exhibition of a white room was in turn a refinement of Immaterial, an empty room exhibited in May 1957 at Colette Allendy's gallery to show the most basic presence of pictorial sensibility. The white paint of the Void rooms is now added only to make the room even more empty, the basic atmospheric force of painting even more evident.

Klein's first proposal for the retrospective exhibition includes a white Void room as part of the documentation of his evolution towards the immaterial. The room is both a historical document, a record of his previous installations of Void rooms, and a necessary act of erasure, the dissolving of solid architecture that makes each leap into the void, and the ultimate the leap to Air Architecture, possible. Klein has himself photographed inside the Void room in overexposed images that efface the corners and surface texture of the room, the last traces of its substance, so that he appears to be already floating in space. The cool space without substance inside Mies's house and the roaring fires outside it reframe the whole building, redirecting the experience of the space and the ambitions of architecture. The ultimate leap is prepared.

A month after the exhibition closed Klein goes to New York and writes the *Chelsea Hotel Manifesto*, once again tying all his different projects into a singular quest for the void. Having continuously painted monochromes for all his fifteen years as an artist and developed *"the architecture and the urbanism of air"* in a way that *"transcends"* the traditional definition of the words *"architecture"* and *"urbanism,"* he contemplates the next step. Just as painting *"no longer appeared to me to be functionally related to the gaze"* of a subject detached from it (because it takes its real force from the intangible atmosphere that passes through the infinitely porous limits of subject and object), architecture likewise takes its force from the endless, intangible, and invisible flows of atmosphere between people and space. Man *"will be able to conquer space-truly his greatest desire-only after having realized the impregnation of space by his own sensibility…. It is our true extra-dimensional capacity for action!"* Having spent his career as an artist constructing himself as a narrow bridge suspended between the material and the immaterial, between the outer visible limit of the solid building and the seemingly empty void into which he jumps, Klein readies himself to do it again. Unaware that he has only another year to live, the young artist patiently retraces his step in yet another intellectual retrospective, stepping all the way back to his first works in 1946 in order to prepare for one more energetic jump, one more leap into the immateriality of the void, one more leap towards a new architecture of atmosphere, but a leap that would have to be made by other architects:

> Having reached today this point in space and knowledge, I propose to gird my loins, then to draw back in retrospection on the diving board of my evolution. In the manner of an Olympic diver, in the most classic technique of the sport, I must prepare for my leap into the future of today by prudently moving backward, without ever losing sight of the edge, today consciously attained - the immaterialization of air…. I find myself before you in the year 1946, ready to dive into the void.

Dematerialisms: The Non-Dialectics of Yves Klein. Juli Carson.

I point out Yves Klein to you among the people, in the street. You say: where? Which one? He is invisible.... Klein moves at an equal distance from the intellectual dandy and the proletarian artist.[1] — Pierre Descargues, 1967

Site(ing) Yves Klein

The task of 'site-ing' Klein presents a critical problematic: Where do we situate him? On what historical and critical terms? Across what aesthetic fields and disciplines? It is conventionally agreed upon that Klein worked within the context of the *"neo-avant-garde,"* but this term is itself a temporal oxymoron, pointing, as it does, in two opposite directions. And in many ways, the artist at hand, one committed to *making* the *Void*, is a paradox, too. As such he is a problem, a bad (non) object, straddling the temporal divide between two epistemologies: one characterized by modern dialectics, the other postmodern discourse. On this note, I'll begin with two sites.

First, a historical site: When Yves Klein's posthumous exhibition at the Jewish Museum closed in New York, it was March 1967, just one year before the March 22 movement in France that would form at Nanterre University, lead by Libertarian students Daniel Cohn-Bendit and Jean-Pierre Duteuil, along with a small group of Situationists. At the time, Pierre Descargues claimed Klein fit neither the "intellectual dandy" profile nor that of the *"proletarian artist,"*[2] the very two groups that, in one last dialectical gasp from the Left, would lead 12 million strikers to effectively shut down the French economy in May 1968. He was, in accordance with his notion of the *Void*, dialectically *invisible*. Speaking from neither the right nor the left, Klein advocated a different kind of work ethic, stating, *"I want each individual, whatever he does in France, to produce in a national, enthusiastic spirit, no longer for quantity, but for quality. No more overproduction leading to unemployment and war, but quality superproduction."*[3]

Next, a discursive site: *"The neo-avant-garde,"* Peter Bürger asserted in 1974, *"institutionalizes the avant-garde as art and thus negates genuinely avant-gardiste intentions."* Moreover, he clarifies, *"This is true independently of the consciousness artists have of their activity, a consciousness that may perfectly well be avant-gardiste."* For it is *"the status of their products, not the consciousness artists have of their activity, that defines the social effect of works."*[4] The myth of authentic origin versus fraudulent repetition, a notion that *still* plagues a facet of art production in as much as it does art history, is at work in Bürger's Lukacsian argument. Ironically, it is the same theoretical lens through which Benjamin Buchloh, a proponent of seriality in art

production, would come to redeem certain neo-avant-garde artists, such as the Situationists, at the expense of Klein, who he positioned as the straw-man. Such that, while critical truth cannot be found in the origin of a historical-avant-garde, for Buchloh, it may nevertheless be found in the *reception* of the *neo*-avant-garde. Through this historicist lens, one need only look at the historical audiences that attended Malevich and Klein's respective monochrome projects in order to designate one as materialistically engaged, the other, a product of a *"faded elite"* nostalgia for transcendence.[5] The heuristic nature of Buchloh's polemical claim aside, is this not a displacement of the ontology of artistic intention onto the site of critical reception?

We need, already, to begin again. For, indeed, how can one disentangle, with any clarity, the *"historical"* site of production from the "discursive" site of reception? Which is to say, is critical reception not always, in part, a new site of *production*? If so, then the *"siteing"* of Klein's project, specifically that of his Void project, begins with its inscription simultaneously (and paradoxically) in two places: the work's historical reception (the *"content"* of the critic writing *about* Klein) and its endlessly deferred site of critical reiteration (the *"instance"* of the critic *writing* Klein). Now, as for the historical site, the *Void* exhibition was just Klein's first step in the evolution of a larger body of work on the immaterial exhibited internationally. Subsequent permutations of the *Void* include his contribution to *"Vision in Motion - Motion in Vision,"* a group exhibition at the Hessenhuis in Antwerp, 1959, in which Klein declared an undefined space his work. For the exhibition *"Antagonismes"* at the Musée des Arts Décoratifs in Paris, 1960, two bare installation spaces were declared *"Voids,"* or *Zones de sensibilité picturale immatérielle, "zones"* he would famously go on to sell. And, of course, there was his preparation of the Void, assisted by François Dufrêne, Niki de Saint-Phalle, and Jacques de la Villeglé, at the Musée d'Art Moderne de la Ville de Paris, 1962, in which the paintings were removed from the gallery, the room photographed, and the documentation later published in the catalogue of the museum's annual contemporary art salon, *Comparaisons.*[6] In the end, however, Klein's productive first step defined more than his own practice. Immediately and persistently cited by artists, critics, and art historians, the Void's legacy has been discursively (re)invented across ideological, philosophical, and aesthetic boundaries.

Viewed this way, Klein's *Void* — a stand-in for art production in general — is nothing *in itself*. Rather it is constituted or indexed discursively, the way energy is made visible to the eye by the ocean waves that index that energy's movement. But this metaphor is already flawed, for such an ocean of discourse is not a homogenous body, but a site of heterogeneous theoretical/historical impulses competing to define a trajectory for art production. What better object, then, to showcase the discursive site than the non-object of Klein's *Void*? For this simple gesture, the emptying out of a room *for view* has proliferated itself through art history and practice over the past forty some years. An effort to site Klein might thus begin with the reception of Klein's *"original"* gesture in select sixties and seventies art practices. I do so, of course, with the caveat that we keep a critical eye on the historical conditions of the present reading.

One Void After Another

On April 18, 1958, *"La spécialisation de la sensibilité à l'état de matière première en sensibilité picturale stabilisé"* opened at Iris Clert. Subsequently known as the *Void*, the exhibition presented the gallery completely emptied and painted white by Klein.[7] Outside, the windows were painted his signatory blue, and blue drapery was hung around the doorway as the show's grand entrance, at either side of which Klein positioned two Republican Guards in full uniform. In advance, 3,500 cards had been sent out, 3,000 in Paris alone. With the invitation, the addressee received an invitation pass, without which the viewer would be charged 1,500 francs. Klein's logic was that *"the visitors endowed with bodies… will be able to steal some degree of its intensity from my impregnation …. And that, above all should be paid for."*[8]

A year later Klein would describe the operation of the Void as such:

I seclude myself in the gallery alone forty-eight hours before the opening to repaint it entirely in white - on the one hand, to clean it of the impregnations from the last several exhibitions and, on the other, because the action of painting the walls white, the noncolor, temporarily turns it into my space of work and creation, that is, my studio.

Thus, I believe that the pictorial space that I have already managed to stabilize in front of and around my monochrome paintings of previous years will be, from that moment, well established in the gallery space. My active presence in the given space will create the climate and the pictorial radiant ambience that normally dwells in the studio of every artist gifted with real power. A palpable, abstract, but real, density can exist and survive by itself and for itself solely in the empty spaces of appearance.[9]

This *"climate of pictorial radiant ambience"* nevertheless had a material base: several coats of pure white lithopone pigment blended with a varnish of alcohol, acetone, and vinyl resin. From such a base, the internal space of the gallery, painted white, was conceived as being the *"immaterialized"* blue of the gallery's exterior. Hence the retinal base of Bachelard's poetics, cited by Klein: *"First there is nothing, then there is a deep nothing, then there is blue depth."*

But there was another materialist basis for the *Void*, the tumultuous conditions of France at that moment. On April 15, a little more than a week prior to Klein's opening, riots over the Algerian conflict had resulted in the resignation of President Félix Gaillard. And amidst this national crisis, on the evening of April 18, impatient crowds gathered outside Iris Clert's gallery waiting to enter the *Void*, some with cocktails of gin, Cointreau and methylen's blue in hand, until police and firemen arrived to break it up when it got out of control. After the opening frenzy, a media campaign spectacularized the exhibition to the extent that hundreds of people a day would line up to *"see"* the *Void* over the next two weeks. The hype was so big that even Albert Camus would attend the show, leaving a note that said: *"with the*

Void, full empowerment." [10] It was, in the end, an uncanny reiteration of a Lettrist style event with neither the political intention nor the target.[11]

Given this hullabaloo over *"nothing,"* it's not surprising to discover that, according to Debord, Klein had attended the very tumultuous first public screening of his film, *Hurlements en faveur de Sade*, on June 30 at the Ciné-Club d'Avant-Garde in the Musée de l'Homme in 1952. A black and white film with no images, *Hurlements'* sound track consisted of a dialogue of expressionless voices delivered by Gil Wolman, Isador Isou, Debord, Serge Berna and Barbara Rosethal. Thomas Levin argues that the film's *"event,"* ending with the audience's protest, realized the SI credo that the art of the future would be *"radical transformations of situations or nothing at all."* [12] Levin describes the event this way:

> *The image track is literally black and white: when one of the five voices is speaking, the screen is white; during the remainder of the film the sound track is silent, the screen is black, and the entire screening space is dark.... More remarkable still is the fact that the sound track runs during only a total of approximately twenty minutes in a film lasting one hour and twenty minutes. Needless to say, the audience has become bored and nervous, if not violent, long before the twenty-four minute black silence that makes up the final sequence - a sequence that Debord claims was the inspiration for Yves Klein's monochrome paintings.* [13]

It is ironic that Debord, a plagiarist of Georg Lukács and a proponent of *detournement*, would later charge Klein with *stealing* his idea of the monochrome from *Hurlements* (not to mention the ensuing spectacle, we presume), noting *"it is not I who could obscure Yves Klein's glory, but rather what Malevich did much earlier and which was momentarily forgotten by these very same experts."* [14] And yet, Klein didn't do monochromes in order to redo Malevich. Simply, he made them because he *"liked*

the color blue."[15] However, it was most likely Debord's comment, not Klein's, that provoked Buchloh's discursive, performative gesture meant to secure Klein's retrograde status among the neo-avant-garde. Here the spiritualist, there the politico. Pay no mind to the fact that in 1957, after dining at Klein's studio, and upon Klein's offer, Debord would take a small monochrome so that he *"could put it in the pocket of [his] duffle coat."*[16] Rather, it is Debord's relapse into *"author authenticity,"* not to mention his Lukácsian belief in the dialectical development of revolutionary aesthetics, that returns as a symptom in Buchloh's over-determined polemic.

The monochrome issue aside, should we humor a dialectic of aesthetics we are still left with the fact that Klein was the first artist to empty a commercial gallery of its objects as a form of public exhibition. In light of this, Buchloh has recently tempered his former line of critique, noting that Klein's production was more paradoxical than dialectical. The contradiction is this: While Klein reclaims the aesthetic object, conceived as *"self-sufficient and spiritually transcendent,"* it is simultaneously displaced by an *"aesthetic of the spectacularized supplement."*[17] Of course for Buchloh, this is not a paradox to be embraced for its own sake; better to dialectically resolve it. Indeed, when Debord came to a similar realization in 1961, he renounced the critical viability of art production altogether. What remained in 1962, after Klein had died and Debord stopped promoting art, was Klein's contradictory status as the historical-avant-garde's recuperated endgame and the ground zero for a post-avant-garde conceptualist practice known as *"institutional critique."* As Buchloh put it:

> By making his work manifestly dependent on a set of previously hidden dispositifs (e.g., the spaces of advertisement and the devices of promotion), he would become the first postwar European artist to initiate not only an aesthetic of total institutional and discursive contingency, but also one of total submission to spectacle.[18]

Klein's form would thus be redeemed while his intentions would not. Certainly, from the perspective of Walter Benjamin's *"author-as-producer"* argument, one in which the political progressiveness of a given form is directly proportional to the political intentions of the author, this may be a logical conclusion, but it is not an ontological fact. I'll return to this point momentarily. For now, I'll follow this developmental trajectory of the *Void*, implicit in Buchloh's observation.

Such an observation appears to have informed Alex Alberro's handling of the "Dematerialist" branch of American Conceptualism. For instance, of Robert Barry's *88mc Carrier Wave (FM)* and *1600 kc Carrier Wave (AM)* (both 1968), Alberro says: *"Drawing the next logical inference from Yves Klein's 'exhibition of the Void' at the Iris Clert Gallery in Paris a decade earlier, Barry now took electrical currents of varying strength emitted by radio transmitters as his material."*[19] Barry described the work this way:

> The nature of the carrier waves in the room - especially the FM - is affected by people...the body itself, as you know is an electrical device. Like a radio or an electric shaver it affects carrier waves.... [Thus] the form of a piece is affected [by the people near it] because of the nature of the material that it is made of.[20]

In Alberro's hands, Barry's work exhibits an intricate *"site-specificity"* in relation to both the environment and the viewer's presence (or, electrical *"aura"*). A type of *"impregnation,"* to use Klein's word, is thus made by the viewer onto the space of the room. Such that the use of electricity as a medium, with the associated discourse of science that the Conceptualists were so taken with, made Barry's room no less mystical than Klein's *Void*. For the viewer, as Alberro himself notes, had to take the artist's claims on faith because nothing - not the wires and certainly not the carrier waves - was visually detectable in the gallery. In this

Robert Barry. 1969.
"Inert Gas Series: Helium,"
Sometime during the morning of March 5, 1969 two cubic feet of helium was returned to the atmosphere
70

way, the viewer had to seize the embodiment of Barry's piece *solely* with one's mind.[21] Such psychic evocation of a given idea was key to a type of Conceptual art, one stemming from a visual prompt or linguistic proposition in which the *"idea or concept is the most important aspect of the work,"* as Sol LeWitt famously put it in 1967.[22]

But it was not until the censorship of Daniel Buren's contribution to the Sixth Guggenheim International in 1971 that this Dematerialist *"idea"* would explicitly point to museum practice itself, initiating a return of/to the neo-avant-garde interest in the relation between aesthetic form and productive forces. Consisting of two pieces of cotton canvas woven in alternate vertical stripes of blue and white, Buren's *"paintings"* were hung in two places. One, measuring 1.5 meters high x 10 meters wide, was hung across 88th Street. The other, measuring 20 meters high x 10 meters wide, was hung in the museum's center well, suspended from the skylight, stopping a few yards from the floor. As such, the building was the literal support for this piece, making the entire museum a frame for Buren's work, at the expense of an architectural vista. At the request of the other participating artists and prompted by Buren's Situtationist intoned statement that *"the only justifiable action left to* 'artists' *was to expose the ideological workings of the cultural apparatus,"* the piece was removed from the show.[23]

The manner in which Buren's piece embodied key formal aspects of Klein's *Void* (i.e., the work's psychic activation of the museum's exterior vis-à-vis the embodied experience of the work in the museum's interior) is striking. Moreover, Klein's use of the spectacle also resonates in Buren's use of the discursive supplement, enacted in advance through Buren's comments to the media, a supplement that physically ushered the artwork out of the museum in the same gesture that it ushered in a psychic experience of the work *by its negation* after the show opened without it. And in this way, at the same time, Buren makes good on his Debordian statement about the function of the museum made a year earlier: that it makes its mark and imposes its frame on everything. This would be the fundamental claim of what came to be known as *"institutional critique,"* which sought an *"analysis of formal and cultural limits (and not one or the other) within which art exists and struggles."* Artists and institutions might try to hide their ideologies, but as Buren urged *"the time has come to unveil them."*[24]

What's so compelling about Buren's work is his tenacious devotion to formalism as the means of *"unveiling"* ideology, limiting (for the most part) his visual strategy to the presentation of one empty room (lined with strips) after another, always therefore equally evoking Klein as much as Debord. Three years later, Michael Asher would, in turn, make good on this uncanny marriage between Kleinean form and Debordean intent in his installation at Clair Copley Gallery in Los Angeles. For that installation, nothing is added to the room; instead the separation between administration and gallery space was *removed*. This strategy of structural removal or displacement, as a form of *critical presence*, marks a type of site specificity that is not about permanence (in the way of Richard Serra), but rather impermanence, as Miwon Kwon has observed.[25] Moreover, this simple, poetic gesture has been instrumental in founding a formal strategy that goes *"against the grain of institutional habits and desires…resist[ing] the commodification of art in/for the market place,"* opting instead to be *"aggressively anti-visual…or immaterial altogether"* (my emphasis).[26] The immateriality of *institutional critique* thus appears to have been established in the wake of Klein's legacy.

Michael Asher. 1970.
Project at Pomona College Art Gallery

71

Klein's Sense and Sensibility

I did not even want to paint one or several walls any longer, nor to make some sort of figurative gesture like sweeping the room or brushing the walls, even with a dry brush deVoid of paint, NO, I simply decided to appear on the spot at the day of the opening [March 17], in order to say to everyone, in the space reserved for me: "FIRST THERE IS NOTHING THEN THERE IS A DEEP NOTHING, THEN A BLUE DEPTH." [27] - Yves Klein

And still, I suspect we must begin again. By itself, this account is a bit too historicist. Is Klein's legacy *only* to be found in the politico-aesthetic rehabilitation of his formal innovation? Were this to be the end of the story, Klein would teleologically be reconciled in the hands of the dialectical materialists, who have sited him at last, *situated* him, even, in the practices of others.

While the above account locates the union of Debord and Klein in the reception of their legacies within the seventies's institutional critique (Debord's politics thus encoding Klein's form), Sylvère Lotringer instead locates a blur in their initial production in 1960, just one year before Debord would give up negotiating the connection between aesthetics and politics altogether.[28] Perhaps it was the observation that Debord and Klein's projects had strategic proximity, an observation made by John A. Thwaites in *Deutsche Zeitung* that prompted Debord to abandon art. As Lotringer cites, Thwaites had advised a German affiliate group of the S.I. not to dismiss Klein's manifestos out of hand because *"the 'government of sensibility' isn't as far as they think from their 'Situationist culture'…only it's been conceived far more accurately."* Lotringer's essay, *"Consumed by Myths,"* published in the same catalogue as Buchloh's *"Plenty or Nothing"* essay, traces the spaces of overlap between Debord and Klein, a space ostensibly covered up by art historical polemics (or myth). What Lotringer maintains, instead, is a non-dialectical account of Debord/Klein's production, through the discursive act of holding their contradiction in permanent suspension.

Lotringer's discursive intervention begs us to reconsider the *Void's* legacy around paradox rather than polemics in the context of social myth. Should we take Lotringer's lead in the context of Conceptualist art production, Klein's *Void* would then activate a philosophical paradox to our consideration of this form, one more resistant to a dialectical account of the *Void*-as-strategy in the space of Dematerialist practice. For the paradox of Klein's *Void* is that it simultaneously maintained and troubled what philosophers call an intentionality model. By John Searle's definition, *"intentionality"* is that feature of certain mental states by which they are directed at or about objects and states of affairs in the world. This entails the notion of *"prior intention,"* which corresponds to the planning or mental projection of an action, the latter of which, according to Searle, is *"a causal and intentional transaction between mind and the world."* [29] In Cartesian terms such as Searle's, a prior intention can thus be said to initiate a transaction by representing that action before it is taken. Moreover, from this perspective, the action is thus a condition of the satisfaction of a prior intention. Here the (interior) mind, there the (exterior) world, into which the body enacts a prior intention. This model of intentionality is dualistic, maintaining, as it does, a clear split between notions of mind/body and concomitantly inside/outside.

Now, should Klein's *Void* be read under the polemics of the author-as-producer paradigm, the work seems to have made good upon the artist's intentions, albeit in a politically regressive form. This is not because he naively aimed at transcendence per se; rather it is the *manner* in which he *failed* to achieve immaterial transcendence that Klein's complicity with Debord's notion of the spectacle can be indexed. For Buchloh, this complicity was Klein's real political intentionality all along, not immaterial transcendence. The trouble with this reading is that it not only resolves Klein's paradox on the side of polemics (thereby naturalizing the mythological terms of the polemic), it overlooks the manner in which Klein's *"intentionality"* might have been at base paradoxical, in which case his project stands to problematize Marxist and philosophical models of intentionality

alike. For there is an impasse between what Klein wants to produce and what he gets. The fact is, he sets out to produce the *Void* (sincerely or not, it makes no difference) and what he gets is all this synthetic stuff (whether he found this satisfactory or not, again it makes no difference). But, of course, without the stuff - that is, without what Buchloh terms *"spectacle"* - the *Void* can not be. Reliant upon each other as they are, there is thus something *transcendental* about Debord's spectacle in as much as there is something *spectacular* about Klein's *Void*. It's an apt paradox to arise amidst the epistemic shift from modernist notions of political/spiritual intentionality to postmodernist contradictions of such intentionality models. Moreover it's a paradox that Klein relished and flaunted to the chagrin of the historicists trying to locate his critical intentionality.[30] Which brings us back to the Dematerialists.

Should we read Dematerialist practice through the lens of Rosalind Krauss's *"Sense and Sensibility"* essay, we might instead see that branch of Conceptualism as instancing a resolution of the Kleinean paradox on the side of a transcendent, intentionality model.[31] Take, for instance, Barry's interview for Seth Seigelaub's *"Prospect 69"* exhibition, in which he was asked, *"What is your piece for Prospect 69?"* His answer, famously cited by Krauss, was, *"The piece consists of the ideas that people have from reading this interview…the piece in its entirety is unknowable because it exists in the minds of so many people. Each person can really know that part which is in his own mind."* Krauss argues that Barry's notion of the mind is definitively Cartesian because it is based on a privacy model, reliant on the notion of a confined mental space. The problem with this model, she asserts, is that it posits our sensations *against* what is knowable and verifiable through the outside world of conventions. Lurking here is a model of intention as a private internal mental event, whereby the artist *puts* his internal idea *into* the exterior world, such that an exteriorization of an interior pre-existing self is produced. In Barry's terms, here my own mind (interior world), there the interview (exterior world), both of which stand for production. Should we reverse the terms - there the interview (exterior world), here my own mind (interior world) - we arrive at reception.

It is important to note that Barry wasn't the only one interested in the Void, however. By the time of Krauss's essay, 1973, there were other artists who had taken up the same strategy in order to index (in a Kleinean way) a paradox *between* interior and exterior spaces, which problematized the model of intentionality that Krauss charges the Dematerialists as naturalizing. For instance, three years before Barry's *Carrier Wave* piece, Haacke was also experimenting with the environmental interaction between a work and the viewer. However, inverse to Barry's interest in invisible form, Haacke's *Condensation Cube*, 1963-5, indexed the presence of the viewer in the gallery by way of a visible form or *shift*. Consisting of a plexi-glass cube partially filled with water (a few inches worth), the work's *"interior"* would sweat as the temperature rose with an increase of viewers to the exhibition space. The elegance of Haacke's piece relied upon the simplicity in which the delineation between interior and exterior space was blurred as the *"impregnation"* of the viewer's *"self"* was indexed as the work. However, the viewer's interior was not exteriorized here but conflated with the interiority of another body (the work). A vertiginous confusion of inside and outside resulted as the ownership of these private domains was put into perpetual crisis.

This psychic component of Haacke's indexical approach to space, one that is radically anti-Cartesian, has conventionally been over-determined by historians of institutional critique who focus instead upon the architectural component of his art-work. Most famously, Mel Bochner's *Measurement* series (1969) has met the same fate. The manner in which Bochner stages the paradox of figure and ground, interior and exterior, *a priori*

Hans Haacke. 1963-1965.
"Condensation Cube"

72

and *a posteriori* - through the simple act of painting a given wall's dimension onto the same wall - has more commonly been interpreted as pointing to the exterior *"fact"* of the institutional than it does to a crisis of interior psychic space. But it is *precisely* the crisis of psychic space that activated Haacke's brand of institutional critique. For how else could his famous *Shapolsky, et al.* have been activated, had he not been censored for initiating a crisis of delineating between the Museum's inside and outside by psychically connecting the Guggenheim's board of trustees with the slumlords of the Shapolsky reality group? Moreover, such a psychic connection pointed to a *presumed* public *"fact"* not an interior experience.

Indeed, this anti-Cartesian evocation of psychic space would find an architectural medium in the case of Gordon Matta-Clark. I am specifically thinking of his contribution to the P.S. 1 *"Rooms"* exhibition of 1976, a show made famous by Krauss's seminal *"Notes on the Index"* essay on seventies art practice.[32] Entitled, *"Doors, Floors, Doors,"* Matta-Clark's piece consisted of the removal of floor through the first, second, and third floors of the building. As such, a space *between* knowable architectural structures, here the ceiling and floor (and by extension floor and door), is denoted as lack, while connotatively the 'knowable' distinction between figure and ground is problematized at the expense of the viewer's gestalt sense of self. The result is that one *fails* to know *that part which is his own mind*. In Matta-Clark's work, from a Kraussean vantage, the *Void* thus indexes a subject *by its own negation* of the mark, an inverse use of the index commonly seen in abstract expressionism that operated along the logic of Cartesian intentionality models. And it is this notion of the *Void as hinge* - a metaphoric pivot between the opposition of figure/ground, and by philosophic, metonymic connection, between meaning/non-meaning, presence/absence, then/now - that allows Klein's *Void* to *work* discursively beyond his initial intentions.

Should the *Void*, as both referent (Klein) and tactic (Conceptualism), thus be conceived as an index (i.e., as a thing-not-itself), then it would function like Roland Barthes' notion of the photograph: that which can only come to be through a helper text. This is what I've attempted to demonstrate here, how Klein's *Void* and subsequent *Voids* have come *to be* through a series of helper texts in the site of reception. Each instance of the *Void* thus indexes a discursive moment in time (then-as-now), be it in the form of political debate, aesthetic polemic, or philosophical problematic. I've offered only a few sites, but I've meant to cast the die rather than cover the bases, as it were. What we can still see, with just a few sites, is that how the *Void* is helped *"to be"* remains unstable. Some readings tend to privilege one side of Klein's internal paradox over the other, in which case his legacy naturalizes a discrete division between the materialist dialecticians and the spiritual dematerialists. And when the Kleinean paradox is thus resolved in the service of dialectically securing the intentionality of a given art practice, ideology (or myth) is produced. Should we instead embrace the Kleinean paradox, we allow his legacy to work as a problem of form (in both art practice and art history), which, of course, entails problematizing Klein's production on the side of reception *to begin with*. What we arrive at then is a strategy of dematerialism(s), following a legacy of Yves Klein(s), that troubles art historical ideologies as a practice. Again, Klein (the author) is made invisible *through* the mark of his own *Void*, which is not. Like Gordon Matta-Clark's architectural interventions, Klein's discursive author/presence is finally *seen* through its own negation.

Notes.

1 Descargues, Pierre. Yves Klein. New York: Jewish Museum, 1967, p. 15.

2 Ibid.

3 Klein. Yves. "Mon Livre," cited in Sidra Sich, Yves Klein. Ostfildern, Germany: Cantz, 1994, p. 145.

4 Bürger, Peter. Theory of the Avant-Garde, trans. Michael Shaw. Minneapolis: University of Minnesota Press, 1984, p. 58.

5 Buchloh, Benjamin. "The Primary Colors for the Second Time: A Paradigm Repetition of the Neo-Avant-Garde." October 37 (Summer 1986).

6 Sich (see note 3), p. 155.

7 His claim was that he had painted the room alone in an atmosphere of seclusion, but in fact others had helped him. The signified "act of seclusion," then, was literally a discursive supplement. See Sich (see note 3), p. 135.

8 Klein, Yves. "Préparation et presentation de l'exposition du 28 avril 1958 chez Iris Clert," in Le dépassement de la problématique de l'art. La Louvière: Montbliart, 1959.

9 Klein, Yves. "L'évolution de l'art vers l'immatériel," in the Sorbonne lecture, June 3, 1959.

10 Sich (see note 3), p. 140

11 Lettrism, a precursor to Situationism, was led by Isidor Isou who believed that the promotion of public scandals—typically through the disruptions of theatre performances, gallery openings, and film festivals—could traverse the division between artists and passive spectators. An oft cited Lettrist scandal occurred at Easter Mass at the Notre Dame cathedral in 1950, when Michel Moure, dressed as a Dominican monk, stood at the pulpit and made the Nietzschean declaration that "God is Dead." The action concluded with an attempted lynching and massive press coverage. Klein certainly took spirituality, not to mention Pacificism, more to heart than did the Lettertists, for Klein had no flirtation with nihilism or anarchism, let alone radical Marxism. His propensity for playful scandal, however, is something he seemed to have shared with both Isou and Debord.

12 Levin, Thomas Y. "Dismantling the Spectacle: The Cinema of Guy Debord," On the passage of a few people through a rather brief moment in time: The Situationist International, 1957-1972. Boston: ICA, p. 82.

13 Ibid.

14 Debord, Guy. Considerations. pp. 45-46 as cited in Levin, p. 115, footnote, 57.

15 Klein, Yves. Letter to Pierre Descargues. Exhib. cat., Oslo, Tampere, Sydney, p. 131.

16 Bourseiller, Christophe. Vie et mort de Guy Debord. Paris: Plon, p. 112.

17 Buchloh, Benjamin. "Plenty or Nothing: From Yves Klein's Le Vide to Arman's Le Plein," in Premises: Invested Spaces in Visual Arts, Architecture, & Design from France: 1958-1998. New York: Guggenheim Museum, 1999, p. 93.

18 Ibid., pp. 93-94.

19 Alberro, Alexander. Conceptual Art and the Politics of Publicity. Cambridge: MIT Press, 2003, p. 114.

20 Barry, Robert in Ursula Meyer, "Conversation with Robert Barry, 12 October 1969," in Conceptual Art. New York: E.P. Dutton, 1972, pp. 36-38. Cited in Alberro, p. 114.

21 A year later, in an inverted gesture, equally indebted to Klein, Barry would dispense with the gallery space altogether in his work entitled Closed Gallery Piece 1969. The invitation card sent by the Eugenia Butler Gallery simply stated: "MARCH 10 THROUGH MARCH 21 / THE GALLERY WILL BE CLOSED," thus instancing the most extreme disembodiment of viewer.

22 LeWitt, Sol. "Paragraphs on Conceptual Art," Artforum, vol. 5, no. 10 (Summer 1967). An even better link between Klein's interest in the immaterial and the Barry's interest in Dematerialism, one that Alberro does not make, is instanced by Barry's "inert gas" work. Here, Klein's Air Architecture is invoked through Barry's use of an invisible material (gas) that he releases into the desert.

23 For a detailed account of the Sixth Guggenheim International, in relation to Buren's piece specific, see: Alberro, Alex. "The Turn of the Screw." October 80 (Spring 1997).

24 Buren, Daniel. Limited Critiques, 1970.

25 Kwon, Miwon. "One Place After Another: Notes on Site Specificity." October 80. (Spring 1997), p. 91.

26 Ibid.

27 Klein, Yves. "Préparation et presentation de l'exposition du 28 avril 1958 chez Iris Clert," in Le dépassement de la problématique de l'art. pp. 12-13.

28 Lotringer, Sylvere (see note 17). "Consumed by Myths," in Premises.

29 Searle, John. Intentionality: An Essay in the Philosophy of Mind. New York: Cambridge University Press, 1983, p. 88.

30 For a reading of Klein as a troublemaker of intention (in production and reception), see Thierry De Duve, "Yves Klein, or the Dead Dealer." October49 (Summer 1989).

31 Krauss, Rosalind. "Sense and Sensibility." Artforum (November 1973).

32 Krauss, Rosalind. "Notes on the Index: Part 2," in The Originality of the Avant-Garde and Other Modernist Myths. Cambridge: MIT Press, 1985.

Traveling Through the Void. Sylvere Lotringer.

The show of the future is in an empty theater.
- Yves Klein, 1959

Yves Klein's discovery of Gaston Bachelard changed his life. He instantly connected to the child-like and transcendent element of Bachelard's poetics and appropriated for his own use this fabulous line: *"First there is nothing, next there is a deep nothing, then a blue depth."* This was creation as he himself saw it, something coming ex-nihilo before it materialized into anything perceptible, depth in a pristine state vibrating on its own until it turned into the blue void. In 1959, participating *"immaterially"* in a group show in Antwerp, Klein simply read aloud a passage from Bachelard while standing in front of an empty wall. It was enough, it filled the entire room.

Bachelard was the philosopher of *"material"* imagination, but his imagination was immaterial. It ransacked archetypes, mostly Jungian, that lay dormant in the collective unconscious in order to celebrate its own creation. His analysis of the four primary elements-fire, water, earth, and air, especially-fired Klein's imagination and inspired some of his most daring projects. Bachelard was less interested in social life and yet France was experiencing a major change. The consumer society was coming on its own, quickly grabbing and folding everyday life in plastic wrapping. In just a few years it remodeled the entire social landscape, pumping in the mainline new products and new desires. Bachelard's project, it turned out, had been a last ditch effort to revive cosmogonies that were fast disappearing. Consumer society was homogenizing everything by showcasing signs that were timeless and immanent. The Situationists denounced it as *"the society of the spectacle."* Increasingly divorced from nature, consumerism was creating one of its own making, upholding form over contents and system over substance. Bachelard had been doing just the reverse. The two projects were running parallel, but at cross-purposes, and only an artist like Klein could manage to have the two meet, as he did, in the infinite. At once shaman and showman, Klein simultaneously inhabited the two worlds, cosmic and cosmetic, and made them resonate incongruously, but forcefully, with each other.

Klein had his timetable. In the late fifties, as the French were busy quelling a violent rebellion in Algeria, he was waging a war of his own between line and color. In 1955, dismissing realism in painting, Klein devised a new kind of abstraction, relying exclusively on the singularity of color. Klein was, of course, aware of Malevich's precedent. But he merely considered him a *"tourist of space,"* and insisted that it was in fact the Russian artist who had copied his own monochromes. This was the way Klein was; he could convince himself of anything, and others as well. It was never entirely clear whether what he said was directly inspired from above (he was a devout Christian), or just part of a clever career move (he was a gifted salesman). Even Pierre Restany, who managed his career, acknowledged Klein's *"opportunistic cynicism,"* but couldn't help being impressed by his sense of timing and his deep spiritual convictions.

Klein's monochrome paintings were meant to liberate and lead pure color *"to triumph and final glory."* Their radiance had something tangible, like an aura, a receptive condition Klein called *"sensibility,"* in which he felt cosmic energy freely flow. Monochromes were pictoriality in its primordial state, a climate rather than a painting. The color didn't even have to be seen, just perceived as a glorious event. Between the summer of 1956 and April 1958, Klein displayed his cards in quick succession. First he settled his monochromatic choice on the Great Color (ultramarine blue), in effect starting his *"blue period."* Then one year later, in April 1957, he switched to the first *"immaterial"* at the Colette Allendy exhibition in Paris, cleverly bringing the two together in a fiery sublimation. In the garden he set up a *"fire painting,"* sixteen rockets lined up obliquely facing the sky on a blue panel, while the upstairs gallery was left entirely empty, stripping the architecture bare. Lighting the One-Minute Fire Painting gave off an intense blue effect, and Restany was struck by Klein's transfiguration *"as if he had suddenly become another man,"* he said, and of Colette Allendy outbidding him. It was as if

he had just seen the dove of the Holy Spirit escape from the fire. Klein's delirium certainly was contagious. He invited Restany to witness in silence the presence of the *"pictorial immaterial sensibility"* and commune with him in the *Void* (the empty gallery room). At this point Klein's tone changed, *"his facial features hardened: he was pale and tense and betrayed a profound emotion made of solemn joy and a kind of diffuse apprehension."* By means of fire, Restany soberly commented, Klein carried out the transcendence of blue through the Void. This happened one year later, in April 1958, effectively ending the *"monochromatic adventure."*[1]

The *Void* at the Iris Clert gallery was an epoch-making event. And yet it couldn't have been more inappropriate. Rebel generals in Algiers had just staged a coup and everyone expected paratroopers to be dropped over the capital. Paris was wrecked with violent blasts and massive popular protests. It was hardly a time to celebrate sensibility and nothingness. Klein's opening provided an unwitting commentary on the political climate outside. Leaving the gallery, Albert Camus simply wrote, *"After the Void, full power."* Just a few weeks later, General de Gaulle seized power and proclaimed the Fifth Republic.

Klein did his utmost to give his event the largest possible audience. First he thought of parachuting a blue condom-like cover from a helicopter on top of the Obelisk, then settled for a more realistic idea - flooding the Egyptian needle with blue light. It would leave the base in the dark, effectively sending the prickly monument, like a rocket, off in its prime *"mystical splendor."* Blue, in Klein's cosmic imagination, was becoming the *"coagulated blood issued forth from the raw sensibility of space,"* and he rushed to register it as IKB (International Klein Blue). Not surprisingly, the authorization to flood the Obelisk was cancelled at the last moment and Klein ended up painting the walls inside the gallery white to signify the passage from his *"blue period"* to an invisible, intangible, immaterial color.

Klein believed that if he concentrated his energy long enough on a certain space, people would feel the presence of his sensibility. Everything, including thought, occupied space. *"I am a painter of space,"* he declared later, in 1962, removing his *"monochromes propositions"* from Colette Allendy's gallery. "You don't need them anymore," he added. *"People can buy space."* It was something else, of course, experiencing this kind of charged presence among the two thousand people who mobbed the tiny space at the Iris Clert gallery for a fee of 1,500 francs. Two Republican Guards in full regalia stood on either side of the draped entry - the draperies were blue, like the cocktails - giving an official cachet to the event.

Klein loved pomp and ceremony. They reminded him of Catholic celebrations. He regularly paid his devotions to Nice's patron-saint, Saint Rita, and joined in full regalia the Order of San Sebastian, a fifteenth century Rosicrucian sect he discovered in a book by Max Heindel. Klein couldn't resist uniforms. It must have been a relief, too, being contained in strict physical boundaries, when he had so few in his own mind. Heindel advocated levitation, a kind of *"immaterial sensibility,"* and in October 1960, Klein jumped from a mansard roof to the street and *"into the void."* A picture of his soaring performance, somewhat improved, was subsequently published in a made-up issue of *Paris Soir* on November 27, 1960, the day he stole from the history of the world.

The *Void* had stolen the show. The opening turned into a riot with people lined out outside and the police rushing to clear the street, and Klein, imperturbable, regulating the flow with a loudspeaker. Pushing art beyond the limits of the gallery space, he had managed to turn an art event into a street demonstration. The contrast between his mystical yearnings, his flamboyant showmanship, and the political storm gathering outside was bewildering. The show culminated in a huge dinner at La Coupole, where Klein brashly delivered his revolutionary speech.

It was the first leg of his *Blue Revolution*, a program he directly communicated to President Eisenhower one month later in an ultra secret letter dated May 20, 1958, as France, he said, was *"being torn apart by painful events."* To avoid disorder or dicta-torship, he respectfully suggested that a government be quickly be formed in France with *"members of our movement"* under the sponsorship of an international *"consulting body."* The economy would be stabilized through a barter system capable of providing real equality, such that *"the rich man will necessarily be an authentic genius in his specialty."* That, he concluded, *"will simply be justice."*

Two years later in 1960, his friend Arman responded to the *Void* with a manifest-exhibit of his own, *"Le Plein"* (Full-Up), stuffing the same gallery from floor to ceiling with loose trash, bird cages, false teeth, old bicycles, binoculars, broken radios, a gigantic accumulation monumentalizing the wasteful nature of consumer society. It wasn't exactly a critique of the reigning mythology, just a way of crystallizing the collective consciousness of the object, the *"poetry"* of their everydayness.

It was around that time that curator-impresario Pierre Restany had the idea of bunching together Yves Klein with a mixed bag of artists hastily assembled for the occasion under the catch-all name of *"Les Nouveaux Realistes."* The group included his friend Arman, also from Nice, who was doing *"accumulations"*; *"decol-lageists"* Francois Dufrene, an ex-Lettrist, Raymond Hains, who was tearing-up and re-collaging street posters; ex-Surrealist Jean Tinguely, who was doing *"self-destructing object-machines,"* Cesar who was compressing cars, and Christo, who was wrapping up objects. At first Klein balked at the idea. He was doing his best to subtract elements from his work in order to escape social clutter, while they wanted more. But Restany, counting on his *"radiating influence"* on the group, came up with a skewed definition: *"The new realism of pure sensibility."* It was a clever oxymoron if there ever was one.

Klein wasn't above this kind of confusion, and actually thrived on it. He was never afraid of mixing up codes; that was in fact his signature art. Whether there was some kind of schizzy humor involved remains debatable. Klein was intensely serious about everything he was doing, but straight-faced humor was Keaton's art. If there was any humor involved, it must have been imperceptible even to himself, and mostly derived from the situations he created. Antonin Artaud called it *"radical objective humor."* Klein's humor certainly was *"objective,"* if one could look at it from a distance. Unlike Artaud, he wasn't a doomed actor screaming all the way to crucifixion, just a well-mannered young man with bow tie and frock coat. And yet something of that wild delirium kept flickering in his mind.

Restany's group wasn't an avant-garde movement the way the Surrealists had been and the Situationist International now aspired to become. Avant-garde groups grow somewhat organically through shared ideological or esthetic affinities, and Guy Debord was making sure the Situationists were doing that. But they couldn't afford dabbling with politics anymore, let alone with art, as the Surrealists did. Society was becoming massively surrealistic and reality itself was hard to find. It was the absolute invasion of life by images, all the more shocking for happening under everybody's eyes (and not on television). In its most creative period, the Situationist movement was bustling with experiments, ephemeral creations based on collective excitement whose purpose was to loosen up the hold of the spectacle on everyday life. Increasingly, though, they took a harder line and took themselves more seriously, refusing the slightest concession. Debord never tired of lashing on contemporary art (he called Klein's *"incantatory mysticism"* fascistic) holding that no artist or architect - and they were many among them - should practice their art before *"the free reconstruction of society as a whole."* It was a hard line to tow and the Situationists paid dearly for it by repeated exclusions and group paranoia. They managed to go down with colors flying (red, not blue). They were the last avant-garde.

Debord's acerbic critique of the *"neo-avant-garde"* was not unwarranted. The New Realists had no problem with society as it was. They were the vanguard of consumerism in art - the beginning of a long procession of simulacra - and it was fitting that Restany would have, in fact, marketed them, and himself, like a mere product. (Klein rightly objected to the prefix *"new,"* arguing that *"today"* would be more permanent). It was also the first sustained-and ultimately futile-attempt by the French to reclaim their artistic prominence undermined by four years of German occupation and the landing of American gadgets on their shores. The New Realists tinkered with found objects in a light sociological manner, anticipating American Pop art by just a few years. Their attempt paled in front of the more in-the-face art practiced by the new crop of American artists (Jaspers Johns, Robert Rauschenberg, Claes Oldenburg, James Rosenquist, Andy Warhol, etc.) out to celebrate equivocally American consumerism by blowing its objects up to monumental heights. Pop artists licked live the entire pre-Pop group when Restany dared confront them *en masse* on their own turf, in 1962, at the Sidney Janis gallery in New York. Klein's only guest appearance there, in 1961, had been a dismal failure as well. Although he had completed his *"blue period"* four years before, and was now exploring the cosmic dimension of his *"immaterial paintings,"* Castelli insisted that he exhibits his old monochromes. Unaware of Klein's bolt-like progression and of his growing mystique, New York critics dismissed him as an entertainer and an *"idea man,"* which he was (but so was Duchamp). His death in 1962 of a heart attack, at age 34, was the final blow. As Claes Oldenburg said later, *"Klein came too early or too late."*

The New Realists participated in the generalized ambiance of the commodity. And it really was this ambiance that mattered, not the objects themselves. What Klein said of Arman's sculptures could well apply to the group on the whole: *"The object in itself has no importance. It is the surface of a thousand similar objects that alone forms the 'quality against the quantity'."* Klein called it *"the mummification of quantitativism."* This was also true for the

"spectacle" that the Situationists defined as the quantitative development of the images of commodity. Consumerism was the complete absorption of everyday life in a foolproof artificial landscape, a benevolent totalitarism in which social relations among people were not dictated from higher up, but immanent to their lives and mediated by images. *"Not only is the relation to commodity visible,"* Debord wrote, *"but it is all one sees. The world one sees is its world."* New Realism belonged to this world. It was *"capitalist realism."*

This made it even more appropriate that Klein would cancel out images altogether from his paintings and substitute immaterial space to the pollution of material signs. Yet, and this is where *"objective"* humor kicks in, simultaneously he decided to sell his *zones of immaterial pictorial sensibility* as if they were materialized in an object. (The invisible zones, to boot, were carefully numbered in series). For this unprecedented *"transfer,"* as he preferred to call it, Klein had to devise a special protocol. He would turn over his *immaterial zones* to buyers in exchange for twenty grams of fine gold. In return they would get something - not the non-existing artwork, obviously, but a signed receipt. The alleged artwork would be sold *"for the price of gold."* Receipt and gold, paper-sign, and fetishized metal stood for the immaterial zone, and actually replaced it with their own materiality. Klein immediately tackled another challenge: making these signs themselves *"immaterial."* In essence, not only would buyers get nothing to show for (on their walls, or in their vault), but they would be asked to forgo the only proof they had of *"ownership."* There was an element of cruelty in that, and it was pretty radical, too; it went at the root of the *"speculative"* nature of art. How much of nothing can be worth something? This was conceptual art in an extreme form. Actually it was far more outrageous. Conceptual artists were trying to avoid commercialism, Klein was confronting it headlong on its own terms. It was a *"modest proposal"* a la Swift. Dali did something of the kind when he, scandalously, sold multiple replicas of his own signature. *Avida*

dollar to the bitter end. Dali's move was little understood, let alone appreciated - stripping artistic fetishism bare by embracing it (and not criticizing it) is never a popular idea. But this was what art came down to: signs, signatures, fame. And speculations. People weren't buying frames, they were buying fame. So why give them art at all? Warhol gave them glamour as glamour, and everyone loved it as high art. Klein's speculation on the immaterial proved by the absurd that art wasn't what it was supposed to be. Opposing capitalist art, Klein was challenging capital itself to become an art object.

All that was left to do was erase the last traces of the deal. The event was carefully staged, like a religious ritual. It happened by the river Seine, in front of witnesses, with Notre Dame prominent in the background. The receipt, written on a special checkbook printed by the Iris Clert Gallery, was symbolically burnt, and the gold (in thin sheets) *"thrown in the wind"* landed into the Seine. Both were *"returned to nature,"* to the prime elements-fire, air, water-thus restoring the dematerialized signs of capital to its cosmic flows.

That wasn't all. Klein entitled the buyer himself to transfer his *immaterial zone* to someone of his choice, and he insisted that it would double in value. This rule was hardly new: The value of an artwork increases each times it changes hands. This speculative aspect (relative to the market) is generally presented as extrinsic to the art, but here it became purely speculative precisely because there was nothing to speculate on. Actually, the added value was simultaneously *"subtracted,"* because more gold would be *"thrown in the wind."* Besides, the remainder of the gold (one-half was set aside) didn't go to the artist, but was entrusted to one of the witnesses. No one, in other words, got anything tangible from the operation. Yet what was derived from it was exorbitant. It established that a *"non-existent artwork"* could be the object of a real transaction, and destroying the records of the sale a further proof of ownership. The transaction had become a

"gift" (in the Marcel Mauss sense), an open challenge to the idea that anything could simply be exchanged. There was more to the thing than met the eye, and infinitely more so if there was nothing at all to see. It made it an obligation to escalate the exchange even further, destroying in the process whatever possession one might have. The "transfer" was constantly changing forms, and so was the art itself. First an artistic speculation, then a financial transaction, it then turned into an anthropological fiction (a "potlatch," generating prestige) and finally into a free "expenditure" (in Georges Bataille's sense), linking prestige to loss and sacrifice. What Klein, in fact, had been doing was recapitulating step by step the genealogy of value, returning it to its mystical essence. Value existed independently of its materiality. Signs were the stigmata of capital.

Klein has often been accused of being a provocateur. Granted, but a provocation of what? Of art first. Like a conjurer, Klein managed to mobilize all the speculative codes of art without ever materializing its object, questioning the acquisitive impulse that lies behind any materialization of art. (Writer Dino Buzzati, buying his share of the *immaterial zone* directly from Klein couldn't resist hiding a piece of the burned receipt in his pocket. Everything but nothing.) But there was something else; these "gifts" also provoked thinking. Everything, including thought, occupies a certain space endowed with an energy that can be communicated. In that respect, art isn't that different from philosophy, whose purpose is to capture non-visible forces with its concepts. Klein, the untutored mind, was a philosopher brut, like champagne.

Pinot Gallizio, the only Situationist painter allowed to practice his art with a vengeance, provided another proof *ad absurdum* to the problem of the immateriality of art. But he did it in reverse, bringing out instead the total materiality (and materialism) of art. It was probably Gallizio and the Situationists who Klein had in mind in his famous Sorbonne lecture of June 3, 1959, when he mentioned "the artists who have often attacked my way of painting," and insisted that when he "navigated in the sea of sensibility" he wasn't any more interested in any sign or gesture than they were. Klein was explicitly reaching out to the Situationists. To a jeering audience, Klein prophesized, referring to Descartes's automaton, that "painting machines" would soon do the job and churn out abstract art "spectacular to the highest degree." Pino Gallizio already was doing that unabashedly. He fabricated his "industrial" paintings by the mile - actually hand-made on huge rolls with rudimentary "painting machines." They were meant to cover cities and highways and eradicate art altogether through the inflation of the product. The rolls sold by the meter and, to his embarrassment, sold nicely. There was no easy way out of the spectacle. It didn't take much, on the other hand, to exit the Situationist movement, and Gallizio was finally expelled by Debord in 1960 for collaborating with "ideologically unacceptable" forces, just like two other architects, Alberts and Oudejans, accused of having had a hand in the building of a church. It may not be totally coincidental that Gallizio's major exhibit in Paris, "Anti-Material Cave," in 1959, to which Debord himself collaborated, strongly echoed Klein's work. Like Klein, Gallizio had a mythical sensibility allied with a faith in modern science and his "Cave," 145 meters of industrial painting wrapping up the entire interior of Gallerie Renee Drouin, was uncannily reminiscent of the *Void*, unwrapped the year before by Klein (and consequently Armand's "Full-Up"). Gallizio called his show "The Uterus of the World" (a wink at Courbet) and had fashion models parading throughout the space dressed in the same painted material, pretty much as Klein, one year later, walked his stripped models covered with blue paint as part of his great "action-spectacle." It would be difficult to disentangle here what belongs to whom and who is parodying the other. Actually, it didn't seem to matter much, as the Situationists, supposedly, encouraged lifting freely their ideas (yet Debord broke up with

Lefebvre, accusing him of plagiarism), and Klein similarly insisted at the Sorbonne that anyone of his followers could sign his paintings. (Still, he couldn't tolerate that his archrival, Takis, exhibited his aeromagnetic sponges before he did). One thing for sure, they all were tackling the same questions at the same time and often came up with similar solutions to *"non-existing"* problems, as Alfred Jarry might have said. That these problems didn't really exist made them no less important. Klein's *Anthropometries*, blue body-imprints made with *"living brushes"* (the painter didn't touch the canvas) also came back full-circle to the anonymous handprints on the Cave's walls, a vision of Eden regained similarly cast in a technological world. Technology could also be hell on earth and Klein remembered vividly the human shadows that immaterialized on the stone in Fumio Kamai's film on Hiroshima. Gallizio intended to impregnate the spectators' sensibility, but the profusion of lights, colors, mirrors, perfumes, and sounds whose intensity varied with the movement of the viewer, was a rather literal rendition of the Situationist experiential attempt to construct *"a milieu in dynamic relation with experiments in behavior."*[2] Klein's own attempt to create a pictorial ambiance, a mental environment transmitting sensibility independently of any object, was hardly different from the Situationist effort to construct *"unities of ambiance"* by roaming aimlessly through the city. Actually they were related. Only by doing away with any mediation could one directly *"perceive-assimilate,"* in Klein's words, the *"prime-state material"* of sensibility. Both interventions were meant to create ephemeral *"force fields,"* transitory passageways in the spectacular world by applying a certain kind of art to life.

The *"absolute art"* Klein evoked in his lecture would have nothing to do with the kind of ego-driven art practiced *"separately"* in the *"world of the theatre"* by the *"living-dead who surround us in everyday life."* It would be a common effort to develop the *"creative imagination"* (Bachelard) that exists within each person in the face of the universe. (Note *"theater"* and *"everyday life,"*

even *"separation,"* which were the main features of contemporary alienation according to the Situationists.) Contrary to the Situationists, who expected this change to happen through disorientation in the streets, Klein envisaged the construction of the International Sensibility Center, a kind of rehabilitation center for sensitivity training, meant to free individuals from their crippling individualism. Obviously inspired by the spirit of chivalry and medieval guilds revisited by the Bauhaus, the Center would entrust Klein's friends and advisers (including Moshe Dayan for Martial Arts) to teach *"men of heart and head"* a curriculum-enhancing sensibility and give full power to their creative imagination. The *"duty to quality"* cultivated in defiance of widespread materialism (the cult of quantity) was at the heart of the *Blue Revolution*. It was also, in a less elitist way (but this is debatable) the main concern of the Situationists.

Debord invoked *"integral art,"* not absolute art, but the difference wasn't that significant. This art, as he conceived it, wouldn't have the kind of *"permanence"* attributed to art in general. Nothing to do either with the *"lyrical abstract"* of contemporary painting, which claimed to produce emotional effects through free poetic lines and forms. It would be based on *"the atmospheric effect of rooms, hallways, streets"* involved in *"the concrete construction of momentary ambiances of life and their transformation into a superior passional quality."* This art would no longer correspond to any of the traditional aesthetic categories, including architecture, because it would be an integral composition of the milieu. And, Debord added, *"Changing the way we look at the streets is more important than changing our way of looking at painting."*[3] This transformation could only be realized at the level of urbanism, as distinct from architecture.

Klein had come independently to the same conclusion during his German period. In 1959, he was invited by architect Werner Ruhnau to decorate the Gelsenkirchen Opera in the Rhur with a team of artists and architects. Norbert Kricke installed water

sculptures in the entrance, Jean Tinguely covered interior walls with kinetic paintings while Klein himself contributed huge I.K.B. blue monochromes panels and monstrous relief sponges soaked in blue paint.[4] Together with master architect Werner Ruhnau, he designed the air roof on top of the building's cafeteria and fire jets and walls of blue fire. All these elements, air, fire, light, and water, fired his imagination and it wasn't long before he decided to involve Ruhnau and Kricke in a rather insane urban project meant to take art, and society, further toward the immaterial. They simply called it *The Air Architecture in Relation to the Conditioning [climatization] of the Earth*. It wasn't the first time Klein had the idea of altering the urban landscape through punctual interventions. After his failed attempt to illuminate the Place de la Concorde, he seriously envisaged, with the help of architect Claude Parent, blowing fire on various Parisian fountains, materializing the meeting of water and fire. He also graciously offered to paint in blue all future nuclear explosions and rename *"Blue Sea"* one of the many expanses of salted water, unduly called Black or Yellow Sea.

Klein had always been fascinated by levitation and he became very enthusiastic at the thought of using *"air heavier than air"* for his new project. Like Constant's *New Babylon*, air architecture was utopian and mythological. What Klein intended to bring back in our midst was nothing else than Eden itself. So did Constant, except that his own project was more heretical. It was Debord who had prompted its name, a blatant vindication of decadence and revolution. Which didn't prevent Debord, as early as in 1959, from violently clashing with Constant on the question of utopia, which he saw in terms of immediate political action. You have to choose, he dropped, *"between a description of the Golden Age and the austere period of its preparation."* Being an architect, and not a Messiah, Constant saw no reason to shelve his project. He decided instead to devote himself, *"instantly and without delays"* to the detailed description of *New Babylon*, using

architectural drawings, collages and photomontage. Not being an architect himself, Klein simply asked Ruhnau and Parent to work out the details.

Both Klein and Constant intended to free people from the heavy envelopes of stone and cement that kept them separated. But while Klein directly aimed at immateriality, sweeping in one bold stroke everything that would stand in the way of the limitless horizon (invariably IKB blue) Constant was more level-headed. He conceived *New Babylon* as a temporary habitation, collective and fluid, constantly remodeled, *"a nomad camp on the planetary scale."* He had an exact model in mind. In 1956, paying a visit to Gallizio in Alba, Italy, he had been struck by a gypsy's temporary encampment made with cases and boards left over by merchants, and decided to build for them a permanent site.

New Babylon was conceived for a society arrived at the stage of utopia, rid of material needs-fully automatized, leisure-and returned to the pure exercise of the imagination. In this utopian society, everyone would be free to create their own lives and give them the shape of their desires. *Homo sapiens* turned *Homo faber* turned *Homo ludens*, everyone would be delivered to *"playtime, adventure, mobility"* on the wildest scale. This nomadic life nurtured by an artificial, entirely constructed environment, was the urban expansion of the Situationist *"drift"* through the bourgeois city that Gallizio had vainly attempted to represent with his grotesque grotto. Like a labyrinth, this en-vironment would translate into a kind of fluid urban space extending to the entire world, *"a structure no longer made of clusters, as in traditional habitat, but espousing the tracings, both individual and collective, of wandering, networks of inter-related units forming chains that could develop and extend in every direction."* It was a far cry from the *"neutral containers of social relations"* implemented after the war by functionalist architects.

Constant. 1959.
New Babylon

73

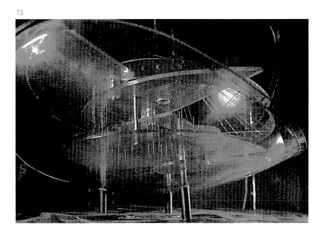

The concept of *unitary urbanism*, developed by Constant and Debord in 1958 to define the construction of situations, precisely opposed rationalized production. It involved *"a complex and continuous activity meant to recreate human environment"* through the exercise of collective creativity. Doing away with the individual and family codes and replacing them with a fluctuating community was the explicit goal of both Klein and Constant. The flexibility of the interior spaces allowed for multiple variations in environment and ambiance within a limited space. The capacity for sectors to alter shapes and atmospheres at will-they would be easily dismantled and built anew-was meant to induce active participation from the occupants. Passivity was a major element of the spectacle.

In Klein's own radiant world, spatial disorientation was replaced by a concentration of energy. His project was even more radical because all the obstacles, walls, partitions, and roofing, everything that privatized space and excluded other kinds of human relationships simply were removed. Made of thick pulsed air, they became transparent, invisible, intangible, in short, immaterial. Klein had young women lying on odalisques made of air lifted from the ground by geysers, levitation on air beds massaged the body. Flows of pressurized air capable of covering huge amounts of land like an immense air roof protected humans from rain or storm and adjusted atmospheric conditions to their desires. This enchanted garden came straight from a chivalry novel (Gauvain saves a damsel's air-walled sequestration), or from Bachelard's *"houses of wind that a simple blow would dissipate."*

And yet, starting from such different premises, it is amazing to see how similar these two projects were. Neither Klein nor Constant thought of turning their clock back: On the contrary, both relied heavily on new technological advances. The Golden Age, and nature itself, they realized, could only return in an artificial state. *New Babylon* embraced modern technology, freedom from material contingencies being the necessary prerequisite for greater organizational complexity and social mobility. Contrary to functional cities, where collective services are integrated in the urban texture, these were concentrated in fully automatized megacenters of production, carefully kept at a distance from the space of everyday life. Klein also chose to keep the technology apart from domestic habitat. He liked abysses in the earth and this became one of the main components of his own master plan. The engineering systems, Parent recalled, were buried *"in immense silos, which surrounded or supplemented everyday life. Everything that was necessary for life outdoors was present there."* Technology, in other words, could be felt everywhere, but it was kept underground, leaving large tracts of unspoiled nature all around for actual human gatherings. (Another compelling reason for burying silos deep in the ground was the ominous nuclear threat.) Constant regrouped social amenities inside that space in autonomous units, or sectors, themselves grouped by clusters, which appeared independent from the outside but actually communicated from the inside. This allowed for a slow and continuous flux of people within each sector and from sector to sector.

Another main element of Klein's project was the highway, which served as a base for all the technical installations. For faster circulation, Constant provided it both from above, on the continuous roof-terraces of the sectors (meant for planes, helicopters) and from under, on the ground level, sectors being generally raised on widely spaced *"pilotis"* above the road. The advantage of this outlay, as Constant saw it, was that each level was independent, clearing the second deck for an outdoor space, *"a second artificial landscape on top of the natural one."* Sectors were loosely connected to each other like large meshes in a wire network; external collective services were installed in these zones, which were free from construction.

In purely formal terms, neither Constant nor Klein's projects were especially original. Like Yona Friedman's three-dimensional *Urbanisme spatial* (1960-62), Constant's *New Babylon* merely covered the historic city with another layer of suspended structures, leaving intact, like Klein, this invasive reality much debated at the time - individual transportation. But fixed forms weren't really the point for *"unitary urbanists"* primarily concerned with tapping on the unused vitalism and creativity of social life. As Debord wrote, what the Situationists were trying to do in architecture was to take *"emotionally moving situations, rather than emotionally moving forms, as the material to work with."* Conceptually, they were breaking away from rationalist urbanism by gathering within a single megastructure a multiplicity of functions, which until then had been kept separate. Instead of isolating humanity in *"green cities,"* or packing them in rat cages, they were doing their best to project in spatial terms the chaotic or radiant image of a new society to come, one more mobile and playful, transient and anarchical, that acknowledged this overwhelming fact of the time - the advent of an artificial, *"constructed"* nature. Air was the new mechanical bride.

Notes.

1 Restany, Pierre. "Yves Klein: Fire at the Heart of the Void," Paris: Journal of Contemporary Art Editions, 1992.

2 Libero Andreotti. "Situationists: Art, Politics, Urbanism," Museu d'Art Contemporani, Barcelona, n.d., p. 30.

3 Guy Debord. "Toward a Situationist International," June 1957.

4 Pierre Restany. "Yves Klein," New York: Harry N. Abrams, 1982, p. 61.

A Conversation. Doug Aitken/François Perrin.

François Perrin: A current debate about architecture is formal, which is reminiscent of that of the early twentieth century. There is a fascination with the use of the latest technologies, which could well suit some concepts of Air Architecture. The problem is that is only a formal experimentation. There is nothing beyond that, whether it is social, political or environmental. I am interested in what comes after this period, how Yves Klein's visions reemerge in other ways, because they seem to be more relevant than ever. There is an aspect of this project I relate to your work *Electric Earth*, where someone walks through the city at night and connects himself to invisible flux. This was one of the principles of Klein's architecture. The materials would be sounds, lights, gas, odors, etc. Things you can barely see, not ones you can grab. Through these elements you create new kind of spaces, which is not an architecture as we know it, but more of an environment, an atmosphere. They are materials of our times, what our society is producing.

Doug Aitken: We are living in a very charged world, one that is in a state of constant flux and transformation. Our perceptions and physical abilities have evolved to a new plateau - one which allows us to be able to take in an accelerated rate of information, to multi-task quicker and to live a more non-linear existence. Each individual's increased perceptual intake speeds culture on a whole. It's a very interesting time and as a result of this speeding up, we've also come to understand and communicate in ways we were not previously able. Through this perceptual evolution, areas like sound, electricity, light - things that are very intangible and immaterial, that are increasingly open for artistic interventions. We have the ability to understand new visual and perceptual languages, in ways we were not perhaps as able to understand fifty or hundred years ago. And much of this comes back to the idea of the narrative structure. If you look at the chronology of the linear narrative, from literature to films, in the early twentieth century and then by the mid-century there was an increasing movement towards breaking the linear narrative structure. If we go back to some of Klein's investigations, there are early investigations in non-linear approaches, not only into art making but into performance and architecture as well.

Doug Aitken. 2000.
"Metallic Sleep"

74

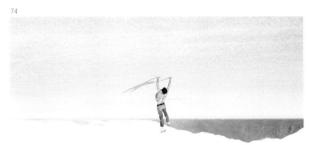

FP: Pierre Restany in his last texts relates Yves Klein and his architecture to the emergence of the Internet. He thinks that Klein would have been happy to live in this period and communicate with these new tools, or be able to visualize his architectural propositions. Technologies were at the origin of Klein's ideas because of the period, the late fifties and early sixties, when people believed that technology would change the world.

DA: Many of Klein's ideas came out of utopian sets of ideals, and as a backlash to this period, our society went into a very cynical phase. We are now revisiting these blueprints for the future in a way, but maybe slightly differently than originally intended. Klein was, perhaps, watching sci-fi films and thinking of the future as this fantastic place, and now we are confronted with a very different reality. That in itself is one issue but more importantly, there is a set of working concepts that has been roughed out by Klein, much in the way of Archigram, Superstudio, or Buckminster Fuller. The value of this is that they exist as future philosophies. It is not really relevant whether or not these pieces were fabricated necessarily, but it is the vision of how they could exist and interact, which is really of value now. In many ways we need to look back on our history and take the seeds that we want to and not the seeds that are given to us, and make our own future from what we find relevant in the past.

FP: In Archigram and Superstudio, there is this idea of the fictional narrative. Architecture is not just a still object; it creates a story and people are part of that movement, very similar to the ideas of Klein or Constant's *New Babylon*. Klein had no architectural education but collaborated with architects who introduced him to the practice. It seems that we're again at a time where artists are referring to architecture.

DA: In a conversation with Rem Koolhass we were discussing the influence of architecture. I found it kind of surprising that Rem had mentioned that he looks everywhere but to architecture. He is incredibly surprised that there is this interest in architecture as a foundation structure by artists. Perhaps the focus in contemporary art onto architectural practice is a relatively new thing. However, we're in a collage culture, and we can't deny that. We can no longer view the sectors of the arts and applied arts as separate worlds. The cross-referencing is fluid, an architectural structure is a like a film as much as it is an actual material form. For example, as you move through a building, you walk down the hallway like an introductory sequence of a film, and then you walk to the first room, which is the first scene, and then you walk through the hallway, which is a transitional sequence.

FP: *"Air Architecture"* is a somehow a generic name. Yves Klein's proposition was also a 'non-architecture', almost a negation of the object of architecture. It was more a project that deals with the situation, where you adapt yourself to the environment. But what is also central to Klein's idea was the cooperation between artists, a concept that reappeared recently through people who privileged collaboration as a work of art.

DA: The idea of the artist as producer more than a craft person is now commonplace. In mediums such as film it's intrinsic to the process, as with much art making. However, in Klein's generation this outward interaction was more rare. Of course this approach eventually blossomed with Warhol generating the Factory in a literal sense, and by the end of the twentieth century, for many artists the evolution had gone out of the studio and into a more open production system. The role of the artist mutated as well to being someone who generates more a network of creativity and concepts, as opposed to the singular act of being in a Void-like studio.

FP: When you think about film practice in contemporary art, it is interesting because Klein was one of the first artists to

Michael Webb, Archigram. 1966.
"Brunhilda's Magic Ring of Fire"

75

document his work through films in a professional way. He would hire some cameraman from the Gaumont Studio to shoot in 35mm his performances or exhibitions. He wanted to leave some traces of his works.

DA: When I think of Klein's work, it is really about traces and a sense of lightness, the impression of something left behind that disappears as quickly as it was there.

FP: That was Klein's idea, that his works would become ashes.

DA: Of course, blue ashes!

FP: Coming back to this idea of film, there is that connection with the practice of architecture. These are two art expressions that deal with production. You are at the center of this network of different knowledge, at the center of a creative process.

DA: The most interesting contribution of Klein's work has nothing to do with the physical aesthetic of it. It is more what is missing rather than what is there; it is more in this absence in space or in the leaving transitory quality of proposals or objects. Klein seems to make a narrative of dust, the idea of creating a story or a suggestion out of something very minimal, very elemental. Klein was a different kind of minimalist, one that uses representational imagery and natural organic elements, but with the goal of a minimalist paradigm. The medium of film is very fleeting and immaterial; it's an image running at twenty-four frames-per-second, it appears and disappears and is only recorded in someone's memory. It is not much different than a performance. Film is a form of invisible architecture. That idea of invisible architecture is at the root of many of these proposals. Unfortunately, many of them were not produced. We can look at their values as pure concept, so in many respects it doesn't really matter if they were made or not. These are footnotes in time, which suggest a certain way of seeing.

FP: I would like to think it is more of an attitude that architects and designers will look at than a formula that explains how to use immaterial elements. A project which cares more for people's future than creating a new style.

DA: It was a radical gesture of *"less is more,"* a radical gesture of generating ideas and concepts out of things we all know. Turning it into a moment that would be unique then disappears. The great contribution of his work is the act of disappearance - like a strange magician pulling out a card when it is least expected.

Venice, California, January 12-19, 2004.

Tangents.

2002 Diller&Scofidio, Blur Building

76

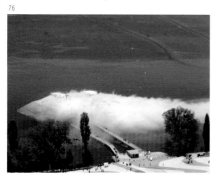

1999 Olafur Eliasson, "Your Natural Denudation Inverted"

77

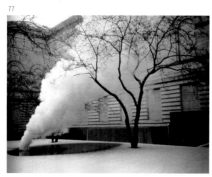

1979 Site, Best Product Hialeah Rainforest Showroom

78

1974 Gordon Matta-Clark, "Splitting: Four Corners"

79

1966 François Dallegret and Reyner Banham, Environment Bubble

80

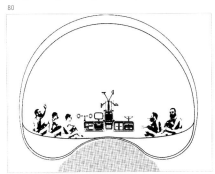

1958 Frank Lloyd Wright, "The Living City"

81

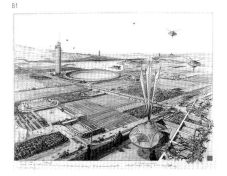

1946-51 Ludwig Mies Van der Rohe, Farnsworth House

82

1929 Buckminster Fuller, Dymaxion House

83

Yves Klein. A Chronology.

1928 *April 28, 7:15 a.m.:* Yves Klein is born in the home of his maternal grandparents at rue Verdi in Nice, France. His parents, Fred Klein and Marie Raymond, are both painters.

1930-31 *Spring:* Taken to Paris to live with his parents.

1932 Returns to Nice to live with his grandparents.

1937 *May 27:* Takes his first Communion in Nice.

1939 Returns to Paris, then goes back to Nice because of the war.

1943 Returns to Paris and lives at 116 rue d'Assas.

1945 *Fall:* Enters the Ecole du Genie Civil in Paris.

1946 *Summer:* Travels to London with his parents. Works in a bookstore in Paris.

1947 *August:* Returns to Nice.
September: Enrolls in judo classes and meets lifelong friends, Claude Pascal and Arman.
December: Klein, Pascal, and Arman discover Max Heindel's Rosicrucian Cosmogony.

1948 *June 18:* Becomes a member of the Rosicrucian Society.
Summer: One day on the beach, Klein, Pascal, and Arman decide to "*divide the world*" amongst themselves. Yves chooses the sky and its infinity.
September: Travels to Italy, visiting Genoa, Pisa, Rome, Capri, Naples, Pompei, and Venice.
November 16: Begins military service in Germany, on Lake Constance.

1949 *October 27:* Discharged from the Army.
November: Travels and works in London.Begins making monochromes and creates *The Monotone Symphony.*

1950 *April:* Travels to Ireland.
Fall: Returns to Nice.

1951 *February 4:* Travels to Madrid to teach judo. Develops first concepts of Air Architecture.

1952 *August 22:* Travels to Japan to learn judo at the Kodokan Institute in Tokyo.

1953 *December:* Obtains fourth Dan Black Belt in judo.

1954 *February:* Returns to Paris.
April: Signs a contract to publish a book on judo.
May: Travels to Madrid to teach judo.

1955 *February:* Starts teaching judo at the American Center.
Spring: Meets Bernadette Allain, a young architect. They start working together.
September: Opens a judo school in Paris. Uses it as a gallery and studio.
October 15: First monochrome exhibition. Meets art critic Pierre Restany.

I think that the color Yellow for example is quite sufficient in itself to render an atmosphere and a climate beyond the thinkable... - Yves Klein

1956 *February 21:* Exhibition at Colette Allendy gallery, Paris.
March 11: Honored as a Knight of the Order of the Archers of Saint Sebastian.

For color! Against the line and drawing! - Yves Klein

1957 *January 2:* Exhibition of works from his *"blue period"* at the Iris Clert gallery, Milan, Italy. Meets artist Lucio Fontana.

> *Each blue world of each painting, though of the same blue and treated in the same manner, proved to be a quite distinct essence and atmosphere, none resembled the other... (topography of the immaterial)* - Yves Klein

March: The architect Werner Ruhnau notices his work at the Iris Clert gallery during a trip to Paris.
May 10: Exhibition at the Iris Clert gallery features a performance involving the release of 1001 blue balloons to create an aerostatic sculpture.
May 14: Exhibition at the Colette Allendy gallery that features sculpture, environments, a fire painting, and an empty room.
May 31: Exhibition, Dusseldorf, Germany.
June 24: Exhibition, London, England.

1958 *January:* Commissioned to decorate the Gelsenkirchen Opera House under the direction of Werner Ruhnau.
April 26, 11:00 p.m.: In the presence of Iris Clert, Yves Klein and the Lighting Director of the City of Paris experimentally illuminate the Obelisk of the Place de la Concorde with blue light.
April 28: Opening of the *Void* at the Iris Clert gallery. This same night he pronounces the discourse of the beginning of his *"Pneumatic period"* at the Coupole. He also receives the book *Air and Dreams* from Gaston Bachelard as a gift for his thirtieth birthday.
August: Meets Rotraut Uecker (whom he later married) in Nice, France.
October: First experiment with Ruhnau on the *"air roof"* in Gelsenkirchen.
November: Proposes project for covering a ruined church with air in Bad Hersfeld, Germany.

1959 *March 17:* Presents an *"immaterial"* piece for a group show at the Hessenwuis in Antwerp, Belgium.
Spring: Begins working with architect Claude Parent on drawings for Air Architecture.
May 29: Group show, *"Artists and Architects of Gelsenkirchen,"* at the Iris Clert gallery.
June 3: Delivers lecture at the Sorbonne on *"The Evolution of Art Toward the Immaterial and the Architecture of Air."*
October 12: Writes to Philip Johnson requesting that he and Werner Ruhnau be invited to the United States to lecture on the *"architecture of air."*
November 18: First sale of a Zone of Immaterial Pictorial Sensibility.
December 15: Opening of the opera house in Gelsenkirchen, Germany.

1960 *January 12:* First *Leap into the Void* at the Colette Allendy gallery.
March 9: Performance at the Gallerie de France including antropometries and The Monotone Symphony.
May: Obtains patent for the color *International Klein Blue* (IKB).
Summer: Makes the first cosmogonies using natural elements such as air, rain, and sand to create imprints on canvas and paper.
October 23: Photography of the *Leap into the Void.*
October 27: Founding of the group of artists deemed the New Realists by Pierre Restany in Klein's apartment.
November 27: Creates the *Theater of the Void* and distributes the newspaper *Dimanche* for one day.

1961 *January 14:* Exhibits monochromes and fire at Haus Lange, Krefeld, Germany.
April 11: Travels to New York for exhibition at Leo Castelli Gallery. Writes the *Chelsea Hotel Manifesto.*
May 29: Travels to Los Angeles for an exhibition at Dwan Gallery.
July 18: Produces fire paintings at the Gaz de France factory in Paris.
November: Makes planetary reliefs using 3-D relief maps from the National Geographic Institute.
December: Designs fountains of fire and water with architect Claude Parent.

1962 *January 21:* Marriage to Rotraut Uecker, with ceremony documented on film. Pierre Henry records *The Monotone Symphony.*
March 7: Air Architecture is presented at Musée des Arts Décoratifs in Paris.
June 6: Dies of heart failure at his apartment in Paris.
August: Birth of his son, Yves, in Nice.

Bibliography.

Writings of Yves Klein.

Yves Klein : *Dimanche 27 Novembre 1960, le journal d'un seul jour*, Paris, Combat, 1960

Yves Klein : *Le vrai devient réalité.* Düsseldorf, Zero Numero 3, 1961

Yves Klein : *Manifeste de l'hôtel Chelsea*, New York, 1961. Paris, Galerie Iolas, 1965

Yves Klein : *L'évolution de l'art vers l'immatériel, Conférence de la Sorbonne, Paris 1959.* Galerie Montaigne, Paris, 1992

Yves Klein : *Le dépassement de la problématique de l'art et autres écrits.* Ecole Nationale Supérieure des Beaux-Arts, 2003,

Monographic Works.

Pierre Restany : *Yves Klein,* Paris, Edition du Chêne, 1982

Pierre Restany : *Yves Klein, Le feu au cœur du vide,* Paris Editions de la Différence, 1990

Hannah Weitemeier : *Yves Klein, 1928-1962, International Klein Blue,* Köln, Benedikt Taschen Verlag, 1995

Sidra Stich: *Yves Klein,* Stuttgart, Cantz Verlag, 1995

Anette Kahn : *Yves Klein, Le maître du bleu,* Paris, Stock, 2000

Jean Michel Ribettes : *Yves Klein contre C.G. Jung,* Paris, La lettre volée, 2003

Catalogues.

Yves Klein, A Retrospective, Houston, Institute for the Arts, Rice University, 1982

Yves Klein, Paris, Editions du Centre Georges Pompidou, 1983

Yves Klein, Oslo, Museet for Samtidskunst, 1997

Tinguely's Favorite: Yves Klein, Basel, Museum Jean Tinguely, 1999

Yves Klein, la Vie, la Vie elle-même qui est l'art absolu, Nice, Musée d'Art Moderne et d'Art Contemporain, Paris, T.A.T., 2000

Yves Klein, Long Live The Immaterial, Nice, Musée d'Art Moderne et d'Art Contemporain, New York, D.G.E., 2000

Yves Klein, Naturometries, Köln, Galerie Gmurzynska, 2002

Das Gelsenkirchener Theater, Werner Ruhnau, Yves Klein, Baukunst, 1992

Yves Klein - Werner Ruhnau, Dokumentation der Zusammenarbeit in den Jahren 1957-1960, Verlag Aurel Bongers Recklinghausen, 1976

Spiritualité et Materialité dans l'œuvre de Yves Klein, Prato Gli Ori, 2002

Photo Credits.

NASA/GSFC/JPL, MISR Team : 1
Courtesy, The Estate of R. Buckminster Fuller: 69, 83
Superstudio: 2
Droits réservés: 3, 5, 6, 8, 18, 19, 20, 21, 41, 42, 43, 44, 45, 46, 47, 48, 49, 53, 54, 55, 64
François Perrin: 4, 33
Paul Sarisson: 7
Yves Klein, ADAGP: 9, 10, 11, 26, 52
Charles Wilp: 12, 13, 14, 15, 16, 17, 22, 23, 24, 25, 38, 50, 51
Harry Shunk: 27, 28, 29, 30, 34, 35, 36, 56, 57, 58, 60, 66, 67, 68
Rotraut Klein-Moquay: 31, 32
Hans Haacke © 2004 Artists Rights Society (ARS), New York/VG Bild-Kunst, Bonn: 37, 72
Bernard Wember: 39, 40
Louis Frédéric: 59, 61
Gilles Raysse: 62, 63
Yves Klein Archives: 65 (Photograph Jean Michalon)
Robert Barry, Courtesy of the Artist: 70
Michael Asher: 71
Constant: 73
Doug Aitken/Gallery 303: 74
Archigram Archives: 75
Diller+Scofidio: 76
Olafur Eliasson: 77
SITE: 78
Gordon Matta-Clark© 2004 Estate of Gordon Matta-Clark/Artists Rights Society (ARS), New York: 79
Dallegret/Bahnam © 2004 Artists Rights Society (ARS), New York/ADAGP Paris: 80
Mies Van der Rohe © 2004 Artists Rights Society (ARS), New York/VG Bild-Kunst, Bonn: 81
The drawing of Frank Lloyd Wright is Copyright © 1958, 1988, 1998, 2004 The Frank Frank Lloyd Wright Lloyd Wright Foundation, Scottsdale, AZ. : 82